SPECIAL EFFECTS PHOTOGRAPHY

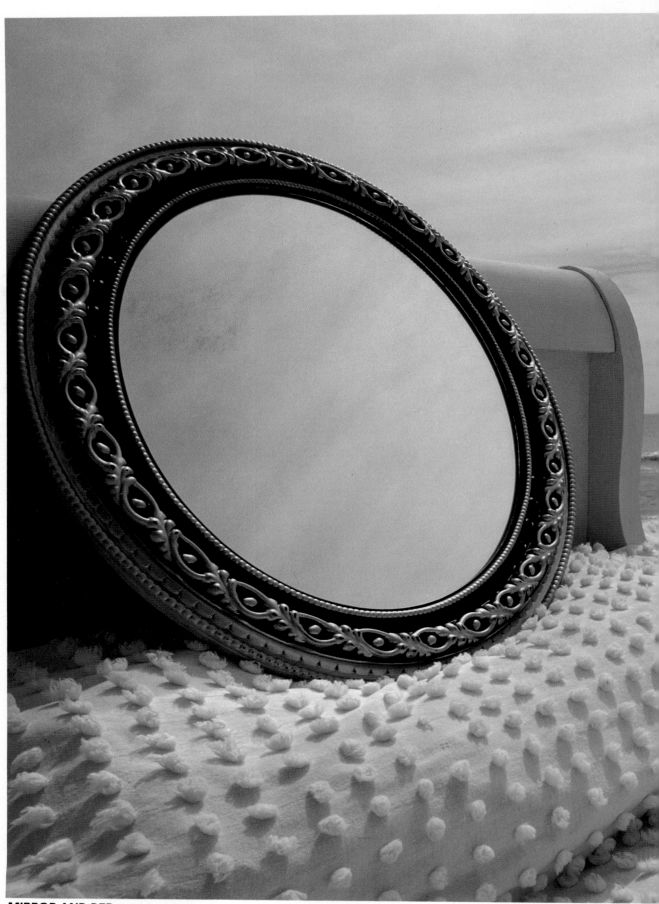

MIRROR AND BED © Michael de Camp

SPECIAL EFFECTS PHOTOGRAPHY

by Kathryn E. Livingston

Amphoto
American Photographic Book Publishing
An imprint of Watson-Guptill Publications/New York

ABOUT THE AUTHOR

Kathryn E. Livingston, a New Jersey—based freelance writer, received her B.A. at Kirkland College and her M.A. at Hunter College in New York. She is the former managing editor of *American Photographer* magazine, where she continues as a contributing editor. Ms. Livingston has written on the subject of photography for such publications as *Parents* magazine, the Polaroid *Newsletter for Photographic Education*, and *US Air*, and was the co-author of *Photographing Your Baby* (Eastman Kodak/Addison-Wesley).

Editorial Concept by Marisa Bulzone
Edited by Donna Marcotrigiano
Designed by Areta Buk
Graphic Production by Katherine Rosenbloom

Copyright © 1985 by Kathryn E. Livingston

First published 1985 in New York by AMPHOTO, an imprint of Watson-Guptill Publications, a division of Billboard Publications, Inc., 1515 Broadway, New York, NY 10036

Library of Congress Cataloging in Publication Data

Livingston, Kathryn E.
 Special effects photography.

 1. Photography—Special effects. I. Title.
TR148.L57 1985 778.8 85-13522
ISBN 0-8174-5883-2
ISBN 0-8174-5884-0 (pbk.)

Manufactured in Japan

1 2 3 4 5 6 7 8 9 / 90 89 88 87 86 85

CONTENTS

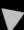

INTRODUCTION

Photography has always been closely tied to the concepts of time and place. Whether we are looking at an enduring landscape by Carleton E. Watkins or a contemporary image made by a globe-trotting photojournalist like David Burnett, we are conscious of photography's undeniable power to communicate the meaning of a particular moment. A photograph by Walker Evans or Ansel Adams may elicit an intense feeling of recognition, a resounding awareness of a certain place. Even if we have never been on this dusty southern back road or have never crossed this stretch of the great Yosemite, looking at these pictures makes us sense that we have been there; that we would know the feeling we'd have if we were to go there now. The documentarian and the fine art photographer each inspire a similar kind of wonder; how were they able to see and capture so remarkably a moment that we could have seen too, if only we had known where and when to look?

When we come across another kind of picture, however, portraying a place or a moment that previously existed only in one photographer's mind, we may be overwhelmed sheerly by the technical aspects of the image. Our sense of time and place, so crucial to our understanding of the photographic medium, may become disjointed. There may be little or nothing comfortably familiar in the image, and our perception of the moment, the time of day, or the exact location may be completely distorted. Instead of asking how the photographer was able to capture such beauty and emotion, we may ask ourselves an embarrassingly pedestrian question, perhaps even scratching our heads unfetchingly as we

intone; how *did* he do that? Suddenly the entire basis of our love for photography may turn from meaning to method, and we may be tempted to risk almost anything in return for a simple explanation of how the moon ended up in the Atlantic.

How *is* the question that seems to arise whenever special effects photography is mentioned, and in part, that is the question that this book intends to answer. But more importantly than how, the interviews with the following eight photographers will answer why. It is not the choice of film, lenses and shutter speeds, but rather the peculiar meanderings and imaginings, the odd juxtapositions and the bizarre fantasies of the special effects vision, that are the key to this genre's deepest secrets.

As Manhattan photographer Bruno states, "It's not just knowing how to do it, anyway, but doing it" that makes the picture. And for that reason, perhaps, he and the others in this collection are willing to discuss the kinds of techniques that many photographers guard even more carefully than their credit cards. But as West Coast special effects artist Jayme Odgers points out, even if he revealed every minute detail of how his pictures are made, the chances that anyone would ever be able to duplicate them is highly unlikely, for only Odgers thinks just like Odgers. Understanding the techniques will help us gather an array of valuable clues, but the solution to the mystery of these pictures will be found only in each individual photographer's unique way of thinking. The willingness to experiment, to learn by trial and error, and to maintain and nurture an inventive spirit is more essential to the special effects

photographer than a studio filled with state-of-the-art equipment. Like martinis or California, special effects photography—perhaps more than any other form of the medium—is a state of mind. What others can learn from these photographers is an attitude, the creative attitude necessary for a successful special effect.

So what is a special effects photograph, anyway? We can begin by stating what it's not. A special effects photograph is not anything that lacks dimension, visual appeal, or magnetism. It probably isn't a photograph that looks like your mother made it at your fifth birthday party. Nor is it a picture characterized by a lot of gray-to-black zones. And it isn't a photograph that was shot with a twinkle filter.

A special effects photograph is, however, a picture that is made, usually, by some type of physical manipulation, either in the camera or in the copying device. Some of the images in this book, however, especially those made by Michael de Camp, require no complicated photographic tricks. Instead, de Camp's photographs are products of a special perception, an uncommon way of seeing that results in a surprising sense of scale. Often using the same camera and lens, props found in novelty shops or constructed by hand, de Camp employs special effects to create his own reality rather than to enhance the world that we know.

In contrast, the photographs made by special effects photographer Steve Grohe, who works in his Boston studio, are primarily high-technology, computer-related images. The technique requires an 8×10 camera that is mobile, a pin-register enlarging system, a battery of lenses and props,

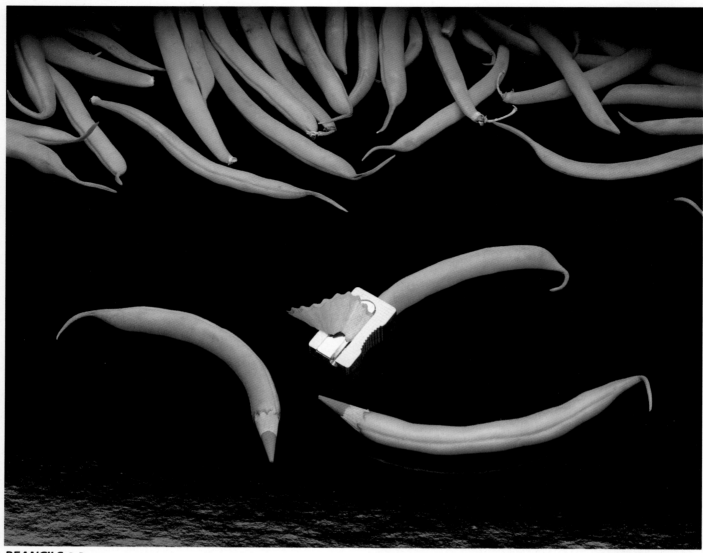

BEANCILS © Bruno

and a knack for combining the laws of physics with the concerns of art. If we were to base our definition of a special effect on the work of Los Angeles-based Jayme Odgers, we would have to conclude that it's something that appears to be upside down, inside out, and sideways at once, and just maybe has some airbrushing. Odgers, who studied graphic design before he became a photographer, is an admitted maverick who has no hesitation about bringing his knowledge of painting and graphic arts into the realm of the photographic print.

Judging by the work of Seattle photographer Jim Cummins, a special effects photograph could be defined by its ethereal, elusive veil of light—and in his case, it's also most likely a fashion picture. But looking at the work of Manhattan photographer Mitchell Funk, the definition would have to hinge upon being in New York City, Nevada, and Iceland at exactly the same moment. Funk can make just about any place more exotic by photographically combining the best of many worlds.

If our definition were formed by looking at the pictures made by Steve Bronstein, Cosimo, or Bruno, all New York City photographers, we would be tempted to conclude that special effects photographs are made in studios and involve model sets, backdrop painters, and the innate ability to turn weak bouillon into hearty boeuf bourguignon—overnight.

In short, a special effects photograph is a picture that is extraordinary, unexpected, and requires either an adventurous technique or an unusual perspective. As Grohe states, "There are no rules." The special effects photograph may or may not honor the traditions of formal art photography, but it can never be limited by them. By its very nature, the special effects photo eludes categorization. Some may insist that it applies only to photographs manipulated in-camera. Others may say that an abstract image made when a sports photographer attaches his camera to a racing car or when an aerial photographer hooks his equipment up to the wing of an airplane is a special effect. The methods, like the effects

themselves, are endless. But however broad—or narrow—our definition, one common quality must be evident: the ability to alter our perception of everyday surroundings.

The effect of such a photograph on the viewer is quite similar to awakening from a pleasant but unlikely dream; when you first wake up, it seems quite plausible that you were just skipping across a field made of blue cotton candy while a friendly green rhinocerous strews your path with marshmallows and strawberries. Of course, after a few moments the absurdity of such a scene begins to overtake you, but nevertheless you may think fondly of strawberries for the rest of the morning. Like a dream, the special effects photograph lures the viewer into a world of frivolous confusion, where things aren't what they seem—but who cares? What matters is that the fantasy (or the photograph) has created a new experience, a different place, or a serendipitous feeling. This type of photography is, in many ways, a medium of pure enjoyment—a mixture of visual excitement, graphic interplay, and symbolic message.

Once upon a time people believed that photographs told the truth. Sometimes pictures don't lie, but these days it's just as likely they'll be telling tales as conveying facts. Within the special effects framework, tiny elements appear to be larger than life; ordinary colors become blasts of vibrant light; places we have never even thought of are suddenly here to see. "To create something that never before existed and in all likelihood will never exist again," as de Camp says, is the special effects photographer's phenomenal talent. It is this act of creating that makes the special effects artist's work so demanding and so satisfying, for he must not only persuade us to believe, but must so perfectly imbue his image with magical allure, that we want to believe.

Back in the 1920s when Man Ray first experimented with photographing silhouettes and objects by exposing sensitive paper to light, creating the photogram—or "rayograph" as he called it—no one may have thought of

using the term special effects. But is was then, or perhaps even before then—when in 1857 Oscar Gustave Rejlander combined thirty separate negatives to create his controversial photograph Two Ways of Life, or in 1917 when Alvin Langdon Coburn, the noted pictorialist, attached a kaleidoscopic mirror to his camera lens to render an abstract picture he called a vortograph—that special effects were really conceived. Our contemporary understanding of this genre may not allow the inclusion of such pioneers on our special effects "who's who" roster, but the special effects mentality—the willingness to investigate, to change, and to find a way no matter what—has characterized photography since its inception.

Truth is stranger than fiction, as the saying goes, but the special effects photographer has always attempted to prove the saying wrong. Like the fantastical painter Hieronymus Bosch, writers like Jonathan Swift and Tolkien, or such musicians as Charles Ives and Mahler, the special effects photographer is a visionary artist. The photographer creates his own sense of what things should be and how elements should relate to each other. Those who, in the name of tradition, criticize this admittedly odd way of seeing the world are only ignoring a vital sign of their times. Some people also doubted Daguerre.

But special effects photography is more closely linked to the future than to the past, for it is in the field of technology and science that this genre has found its greatest expression and potential. A glance at modern advertising photography, as well as the work of such special effect masters as Pete Turner and Michel Tcherevkoff, reveals that the futuristic photograph has become an integral part of daily visual experience. Behind every computer chip, it seems, is a surrealistic glow. Underneath every display terminal is a bizarre dimensional grid. Special effects photography seems perfectly suited to our high-technology vocabulary. As the work of Steve Grohe so clearly indicates, special effects photography is a perfect means of turning complex ideas into an understandable visual language. Using old methods to illustrate new scientific concepts just doesn't seem right. What better way to describe the inconceivable realities of a sophisticated society than to use the photographic approach that is the most technically advanced?

In many ways, art and technology are inseparable companions. The most skillfully designed instruments are often the most visually appealing; elegant inventions may require the inexplicable power of the special effects photograph to accurately illustrate their characteristics. But special effects are not the exclusive property of high-tech advertising photography, though their use may be most evident in that area. One has only to look at the images in this book made by de Camp, or to think of a startling Bill Brandt nude, a strange Jerry Uelsmann scene or a Duane Michals sequence, to realize that the origins of special effects can be traced to many kinds of fine art pictures as well as to commercial advertising imagery.

The photographers in this book have been selected not only because of their success as professional working artists and for their technical virtuosity, but because as a group they illustrate the tremendous diversity of special effects photographs. To advertise products, fashion, computer hardware and software; for record covers, book jackets, personal portfolios, posters, annual reports, catalogs, and simply for artistic expression, these photographers have revealed that special effects can be used for just about anything—and used well.

When a majority of the eight photographers included here began making pictures, special effects were not nearly as pervasive as they are today. But like every other aspect of photography, special effects have become a big business. The trick is separating the special, however, from the merely affected, for as with any popular art there are some who use the techniques without understanding its raison d'être. The best special effects photographers have a refined visual taste. They know—perhaps because of their many experiments or perhaps due to some mysterious sensibility—when an

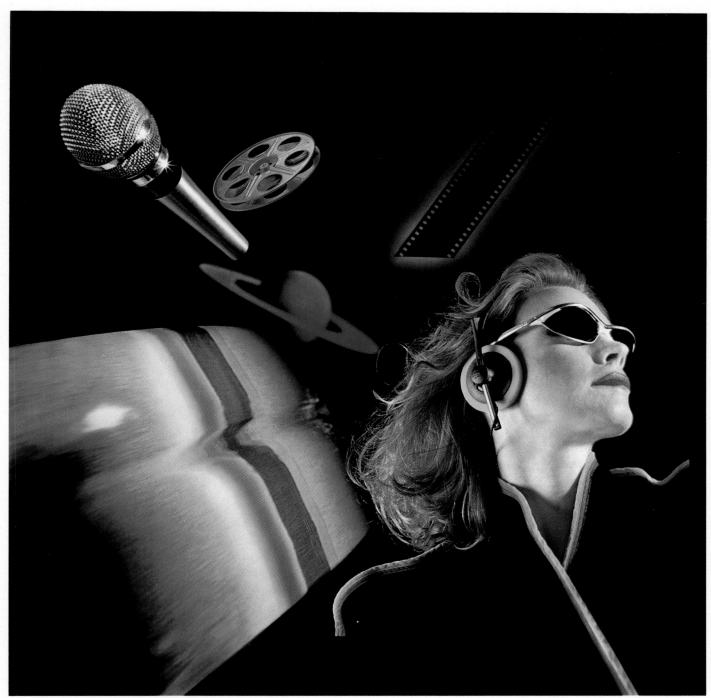

STUDENT TELEVISION AWARDS 1981 © Jayme Odgers

INTRODUCTION

effect is complete and when an effect has been exploited. They know instinctively how much is too much and just how much isn't enough. There may be no set rules about how, but there certainly are standards about when.

So lest it seem that we would turn the world into one giant green-gelled, backlit, Plexiglas bubble, a word of caution. Special effects are not for everyone nor for everything. Each photographer in this collection has stressed this recurring theme; special effects should not be used simply for the sake of using them. No need to artifically turn a bluebird blue or to brighten up a sky that already has a natural, magnificent glow. The purpose of a special effect, they claim, is to enhance reality when needed, to illustrate fantasy, or to strengthen a mood. It is not intended to turn a medium that is inherently capable of abiding beauty into a showcase for polyester pictures. Special effects techniques, as Funk says, won't make a mediocre image look special; mediocrity will remain bland even if craftily covered by a purple haze.

How, then can we know just when special effects are effective? As with most things, experience may be the answer. For Funk, who has always imagined that the place he is in—wherever it is—could be made even more appealing, special effects provide a tremendous outlet for bold creativity. But for Cummins, who uses special effects to heighten mood in his fashion photos, manipulation is not always his favorite solution. Only the needs of the image itself and the particular vision of the photographer can determine when to create an effect and what the right effect will be.

One of the most intriguing qualities of a great special effects photo is its ability to make the viewer experience a double-take. When we watch a professional illusionist perform, we know that the lady hasn't been cut in half, but we can't help worrying anyway. Like magic, a special effect must verge on reality—both visually and conceptually—to be successful. And, as one exceptional photographer once noted, in a sense all photographs are based on special effects because the very process of portraying a three-dimensional world on a flat piece of paper is a magic trick in itself.

An unbelieveable special effects photograph is just as disappointing as a grade B horror film. If a ten-legged creature eating whole cities in one gargantuan swallow is obviously the size of a titmouse, we might as well take our popcorn home and watch the ball game. But if an extraterrestrial being has some human qualities and acts in a logical and intelligent manner while he zaps the Empire State Building in pieces with one stolid gaze, we begin to quiver. The special effects photograph, no matter how absurd the subject matter, must be technically precise. Though the special effect is based on fantasy, reality must somehow be preserved or the illusion will be lost.

That is why all of the photographers in this collection insist upon meticulous attention to detail. As in the most astonishing landscape or the most delicate still life, light is the essential element. A studio sunset must be reminiscent of reality, and a model set must be fine-tuned until it looks large enough to live in. It won't do just to be odd or strange; a special effects photo must be precisely a hairsbreadth on the right side of the impossible. Otherwise it will become a visual joke. As Cosimo, who maintains that lighting is the ingredient that makes or fakes a photograph, says, "It's all common sense." Simulate the qualities of sunlight and your pictures will not only have a life of their own, but a life that is believeable.

The techniques discussed in the following pages serve as a reference guide to a concept rather than an instruction booklet for making a special effects image. Each photograph, as Bruno points out, presents a different problem; there is no reason to assume that a technique that worked once will work aesthetically for every image. Each photographer may have an individual style, and recurring methods and themes may appear in their pictures, but no one has an unchanging formula.

Learning how various photographic problems are solved, therefore, will not

INTEGRATED CIRCUITS © Steve Grohe

INTRODUCTION

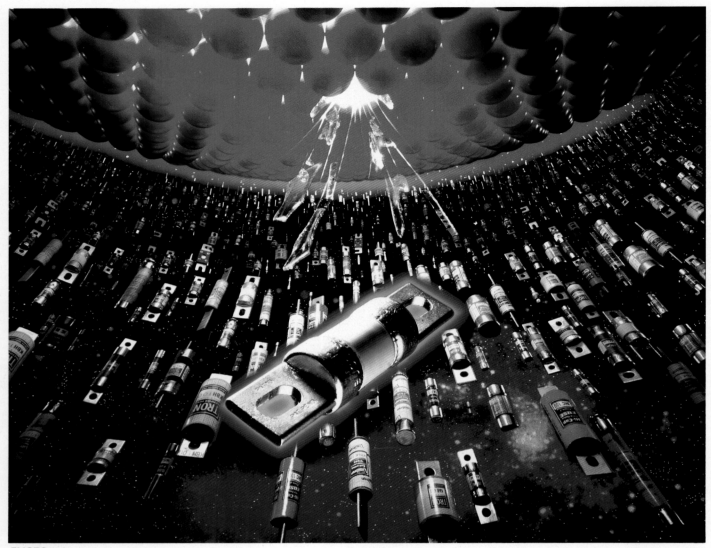

FUSES © Cosimo

provide a cure-all, but it will increase our awareness of the vast possibilities of the special effects approach and of the concept that photography is not a pristine palace whose gates open only to those who will swear on their lens caps that they've never mischievously rewound their film. Even within the world of special effects there are varying degrees of acceptance. Steve Bronstein, for instance, prefers to accomplish as much in-camera as possible, and his pictures have the elegant quality of fine still lifes. Odgers, however, finds it reasonable to airbrush entire elements or to airbrush directly on his subject-objects or even to photograph upside down with a cable release tucked between his teeth.

"Whatever will make the photo work is what I use," says Cosimo, who perhaps most dramatically illustrates the incredible potential of the special effects style for both commercial assignment work and for personal expression. Though Cosimo works in his studio for most shots, his images are no less arresting than images made by Funk, who travels all over the world, or by Grohe, who constructs elaborate technical set-ups. But what all these photographers have in common, rather than a specific modus operandi, is a determination to make their fantasies come true. Regardless of the difficulty or the enormity of the task, these special effects photographers will always find a way to match the image in their mind's eye.

In any genre of photography, there is a prevailing hazard that a particular subject or style will become a cliché. With so many photographers attempting to add a different twist in a very competitive field, it is tempting to rely on a single solution, repeating it ad infinitum. Undoubtedly we've all seen enough bums lying on park benches and children struggling with dripping ice cream cones to last a picture lifetime. In truth it is rarely the subject, but rather the artist's approach to it, that determines the intrinsic value of an image. What is truly exceptional about special effects photography is its possibilities. For that reason, looking at the photographs in this book can

become an inspiration rather than a guide. Just as we may never tire of looking at an Atget garden, even though we have seen a million other pictures of flowery groves, we may never tire of seeing a special effects photograph that expresses an artist's unique outlook. And as the images in this book indicate, there are as many ways of using the techniques and philosophies of special effects as there are photographers with the stamina to remain loyal to their own imaginations.

Perhaps special effects photography can never hope to surpass the beauty of the natural environment, but that isn't really what it's supposed to do anyway. The age-old question of whether art imitates nature doesn't even come up in this chapter of photography's development. The special effects photograph makes no claims on the exterior world other than using it as a takeoff point to explore the interior landscape of the mind. Because photography is so inherently bound to what we see and feel, it may be difficult to make the transition to the idea of photography as what we could or might see. Yet this notion is essential to our understanding of the special effects approach to art.

A master photographer once said that it's easy to learn the alphabet, and when you do, it's quite simple to write. It's not so very hard to learn how to use a camera either. But of course, he added, as any novelist knows, the real challenge lies not in putting the letters on paper, but in making each word relate to the next. The special effects photograph—in fact, any photograph—is much the same. It is the act of communication, not the clicking of the shutter, that makes the image speak. The photographers in this book have all learned to use their methods expertly, and without exception they are skillful craftsmen. But more importantly, they are skillful conjurers who have instilled their pictures with a personal philosophy and style. Because they are the kind of photographers who keep their minds as open as their eyes, these images are extraordinary examples of the wonder and adventure found—and yet to be discovered—in the special effects world.

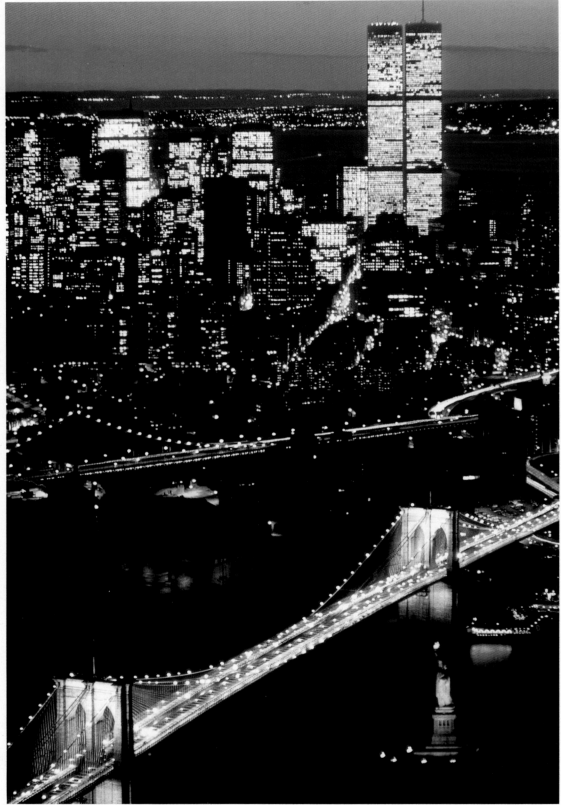

BROOKLYN BRIDGE CITYSCAPE © Mitchell Funk

Mitchell
FUNK

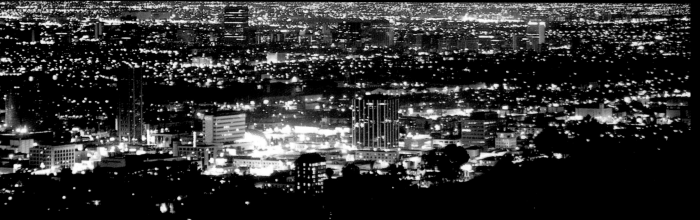

LOS ANGELES MOUNTAIN RANGE

On a trip to Los Angeles, Funk became fascinated by the city's lights but, characteristically, guessed that they could be made even more brilliant. To produce an abstract vision of light, he "painted" the scene with a 200mm lens by haphazardly moving his camera. Then he took a second realistic shot of the city with a 50mm lens. In his files Funk later found a mountain landscape that would effectively anchor the two city scenes. He sandwiched the abstract lights and the mountains and then double-exposed the cityscape beneath them, creating a single vibrant impression of Los Angeles' light fantastic.

Mitchell
FUNK

"My first priority is always to make a good, straight shot," says Mitchell Funk, whose remarkable images seem more likely to have been composed on Neptune than in New York City. In search of the quintessential camel, a sublime sunset, or a dynamic cityscape, Funk sends himself on at least two personal travel assignments a year in addition to the commercial assignments he receives from such clients as IBM, AT&T, TWA, and Nikon. In Hawaii, Australia, Morocco, or Iceland, Funk photographs for several months. When he returns to his Manhattan studio with about 300 rolls of exposed film, he sandwiches negatives and double-exposes film on his slide duplication equipment to create his unique locales. Later he sells his personal work as album covers, greeting cards, illustrations for calendars, or to magazines.

A self-taught photographer, Funk became involved in the medium while he was in high school, after a summer job working in a darkroom. He was soon "hooked" on photography and spent the next few years driving a cab and doing odd jobs while he made pictures in his free time. By the age of twenty, Funk was supporting himself by his photography alone, and his work was appearing in such national magazines as Modern Photography, Popular Photography, and Camera 35. At twenty-one, he shot his first Fortune cover, and today his photographs continue to appear in such major publications as Life, Newsweek, and New York Magazine.

Funk found, however, that journalistic assignments weren't enough to set him apart in the very competitive field of

photography. To attract attention, he began using special effects methods and soon discovered that the reaction was positive. Not only were the 1960s ripe for his kind of futuristic vision, but Funk gained greater satisfaction from improving upon reality. "I was never satisfied with what I saw," Funk explains. "I always felt I could make things look better or stronger."

Funk's method is one of perfectionism; he never attempts to enhance a mediocre image by superimposing an extraordinary scene. For the final special effect photograph to succeed, Funk insists, each separate image used to build the composition must be exceptional. But the key to Funk's success in special effects photography may well be the meticulous attention he pays to the illusion of reality. Though his bizarre landscapes, neon cities, and space-age abstractions clearly are manipulated, the photographic transition between reality and fantasy is always subtle. Everyone knows that the Statue of Liberty doesn't belong under the Brooklyn Bridge, but for some reason it seems quite plausible when Funk places it there. Funk can transform a pebble to a boulder or so perfectly blend two distant landscapes that they appear to have been shot at the same moment in time. "It's all a matter of aesthetic choices," Funk says. "The technology isn't mindboggling, even though it sometimes seems to be. What essentially counts is how a photographer handles light, color, and design. Each element must be combined in a way that is somehow believable."

Funk uses a variety of special effects techniques, but most of his scenes are created through multiple exposure in his slide duplication device or through negative sandwiching. He shoots both in his studio and on location, usually with a Nikon F3 and Kodachrome 25 film, occasionally using filters to produce exciting color variations. When he returns from a trip, he spends days in the darkroom working out possible combinations. Knowing the appropriate sunset to pair with just the right cityscape is a time-consuming art that requires skill and patience, as well as intuition and a keen imagination.

For Funk, the photographic possibilities are limitless; he is able to see not only what something is but, more importantly, what it could become. "What fascinates me most about special effects photography is that there's never an end to it," says Funk. "There's an endless array of relationships to be discovered and explored, and there will always be other ways to interpret form, light, and color." Sometimes he produces a gentle, eerie landscape; at other times, graphic, high-contrast scenes. In his photographs familiar skylines become unknown meccas, and monotone deserts are transformed into sensuous orchestrations of color and mood. The locations Funk reveals in his images are often more beautiful and visually alluring than any we might encounter in the most exotic reaches of the planet. His mind's eye is constantly taking the best of whatever he sees and making it better, mixing and matching until he has created yet another remarkably new and wonderful place.

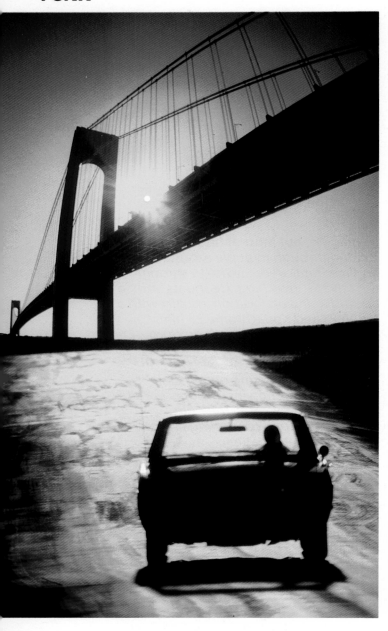

COUNTRY ROAD WITH BRIDGE

On a country outing in Connecticut, Funk discovered this winding, textured road. He photographed it with a 50mm lens, exposing for the road so that the meadow and trees in the background would appear black. Later he decided to create an interesting study of perspective by pairing the road with New York's Verrazano Bridge. He shot the bridge with an ultra-wide 16mm fisheye lens using a yellow filter that matched the natural lighting of the earlier image. Though the perspective in the final sandwiched negative is misleading, the image works because of the similar lighting temperature and the strong graphic composition.

CAPITOL BUILDING WITH ROADWAY

During a visit to Washington, D.C., Funk was impressed by the brilliant glow of the capitol building. He made an exposure with a 105mm lens, using both a soft-focus filter and pale yellow filter. Later he decided the image would be enhanced by a road leading to the building. Funk located a two-minute time exposure made in Florida. He had shot the scene at dusk with a 16mm lens at $f/8$ from a perch on a low-hanging bridge overlooking a busy highway. The long exposure emphasized the moving car lights—white headlights approaching him and orange taillights from cars speeding into the distance.

To add an element of mystery to the picture, Funk asked a friend to stand at the side of the road, providing a mysterious silhouette on the right side of the frame. From his files Funk also pulled an image of a glowing skyline, which he double-exposed on the left side of the image to create a more complicated dimensional effect. The skyline was made on a misty night, using an orange filter and a 20-second exposure. He then copied the three images on his duplicating device to create one magical locale.

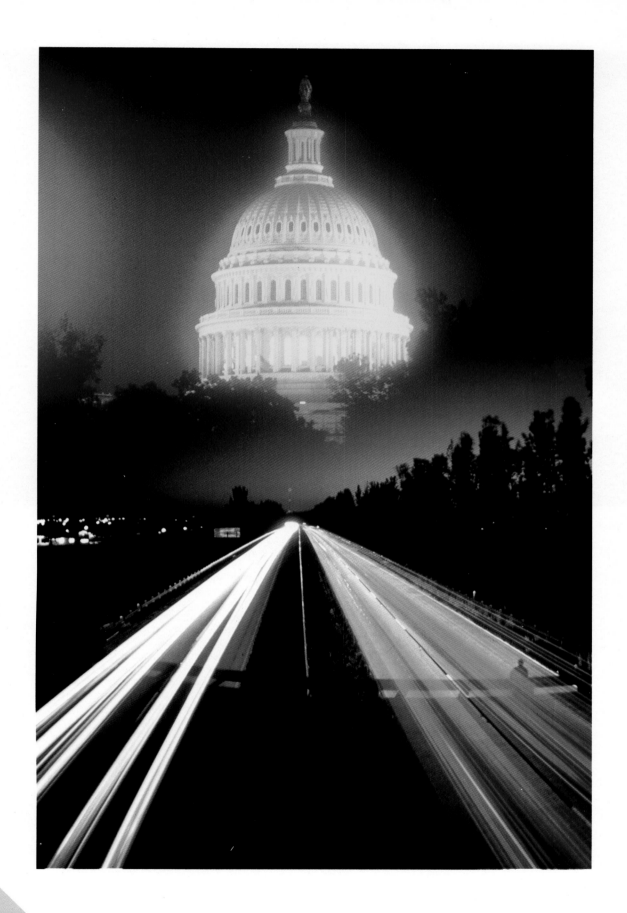

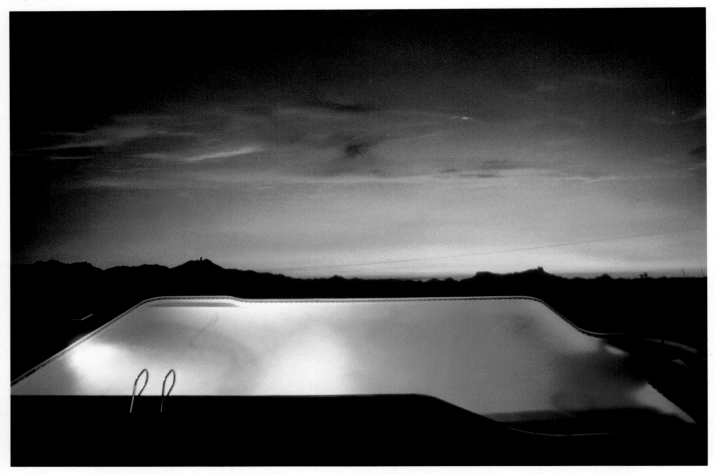

LUMINESCENT POOL

Visiting in Tucson, Arizona, Funk was watching the sunset from a room in a friend's house when he decided to capture its beauty on film. He made a straightforward shot using a 50mm lens. About an hour later Funk was looking out an easterly window when he noticed the strange luminosity of the swimming pool. He immediately judged that the two scenes would make a stunning combination, so he climbed to the roof of the building. He rewound his film, switched to a 20mm lens, and double-exposed the pool in the lower portion of the frame. Funk exposed the image for about 45 seconds, which transformed the gentle, natural flow of the water, illuminated by a pool light, into a swirling, surrealistic movement. The image reveals that Funk doesn't always travel untold miles to discover his compatible combinations. Sometimes it's simply a matter of recognizing the many possibilities for photographic relationships within a single environment.

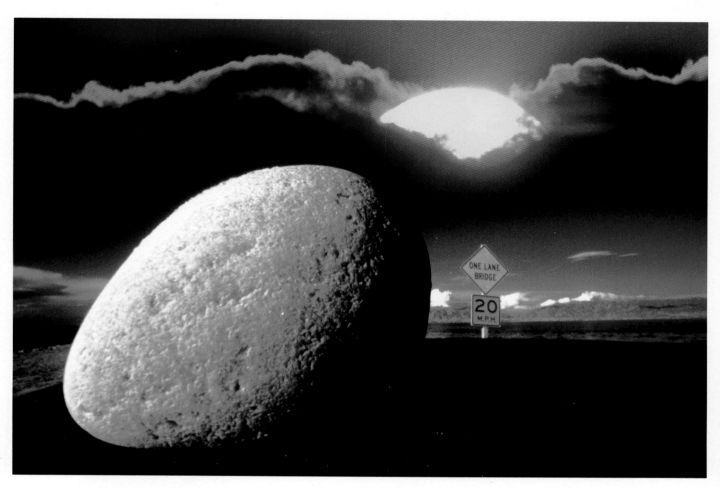

SUNSET AND PEBBLE

During time out on a West Coast assignment, Funk spotted a small, interesting rock and whimsically placed it on the roof of his car. He chose a low-angle and, using a 20mm lens, shot the stone at *f*/22 on infrared film with a yellow filter. The resulting picture sat in his studio for about nine years! One day it occurred to Funk that a secondary dimension of light might bring out the best in the picture, so he scoured his files for a rim-lit sunset. He double-exposed the rock with its black sky background on the sunset image. Because he had photographed the stone at close range with a wide-angle lens, the depth of field provided this distorted sense of dimension and scale.

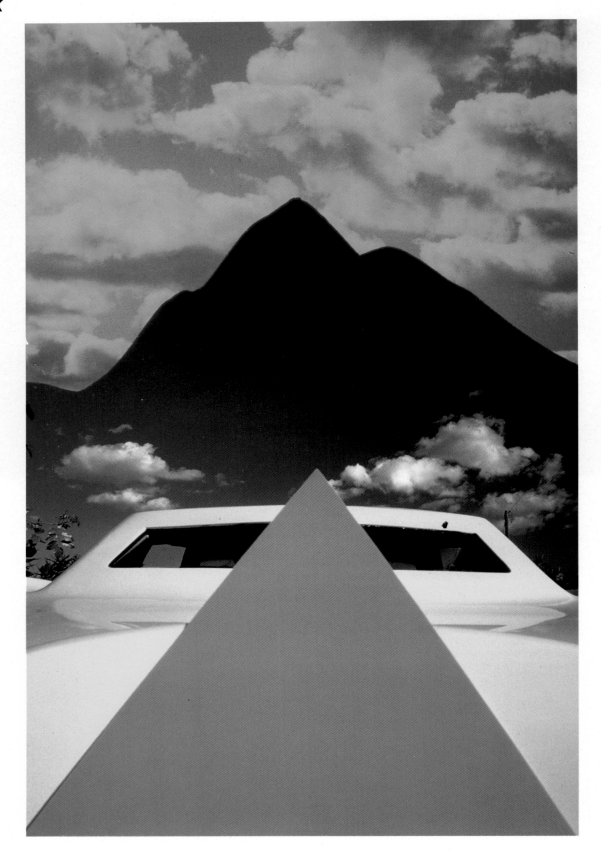

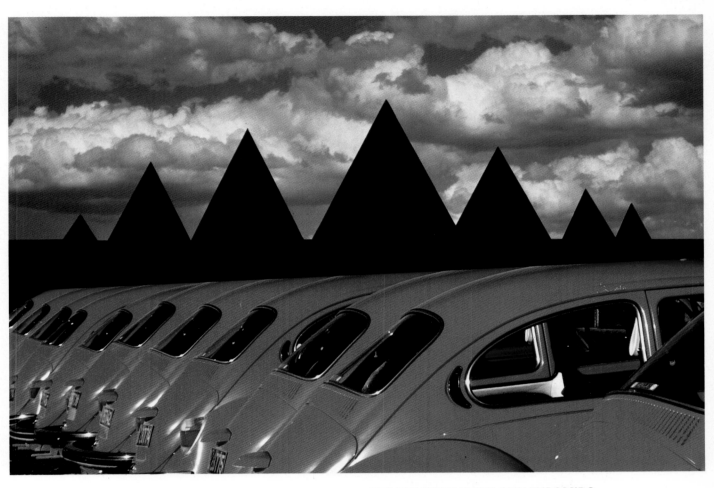

RED VOLKSWAGONS AND PYRAMIDS

At a Volkswagon rent-a-car station in Iceland, Funk noticed this unusual profile of red Beetles. He was immediately interested but knew that the scene could be made even more intriguing through the use of a few special effect techniques. He shot the cars on a bright day with Kodachrome 25 film and a 20mm lens, using a polarizer to turn the rear windows black. Months later, in his studio, Funk cut out balsam wood pyramids with a jigsaw and photographed them with a 105mm macro lens. From his extensive files he gathered some cumulus clouds shot with a 20mm lens. On his copier Funk combined the clouds and pyramids, double-exposing the cars beneath them. The final image reveals Funk's uncanny capacity for turning the unexpected into the bizarre.

CORVETTE WITH ORANGE TRIANGLE

On assignment in Florida, Funk was taking a leisurely drive when he noticed a beautiful yellow Corvette. He asked his assistant to hold a 12-inch (30.48 cm) piece of orange Plexiglas against the car while he got down low with a wide-angle lens and made an exposure in the bright sunlight. The depth of field from his chosen angle allowed for a dramatic distortion of scale. Back in his files, Funk found an image of billowing clouds and double-exposed them against a mountain range using a blue filter to provide a strong contrast ratio. In his copier Funk then double-exposed the picture of the car beneath the landscape, perfectly aligning the tip of the plastic shape with the crest of the mountain for visual balance.

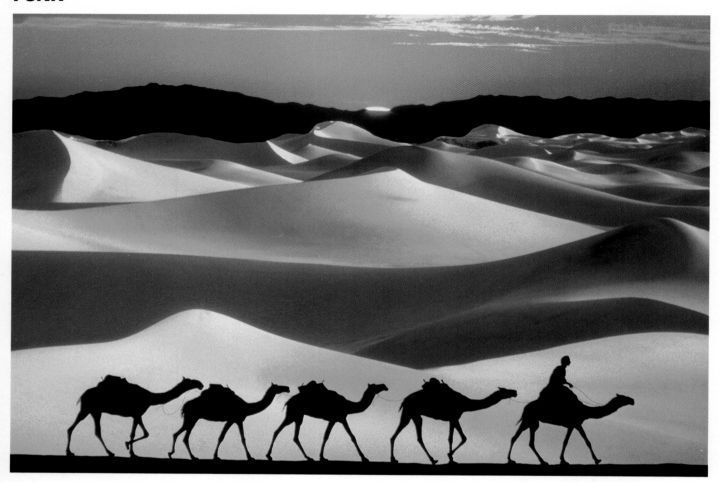

DESERT LANDSCAPE WITH CAMELS

On a trip to Morocco, Funk paid a camel driver to let his camels model. They were shot with a 50mm lens against the sky early on an overcast morning. Funk decided to combine the camels with a photo of rim-lit sand dunes he had made against a dark sky in Death Valley. Funk sandwiched the camels and dunes and then double-exposed a sunset made with a 200mm lens at Newport Beach, California. The photograph brings three disparate locations into an imaginative visual harmony.

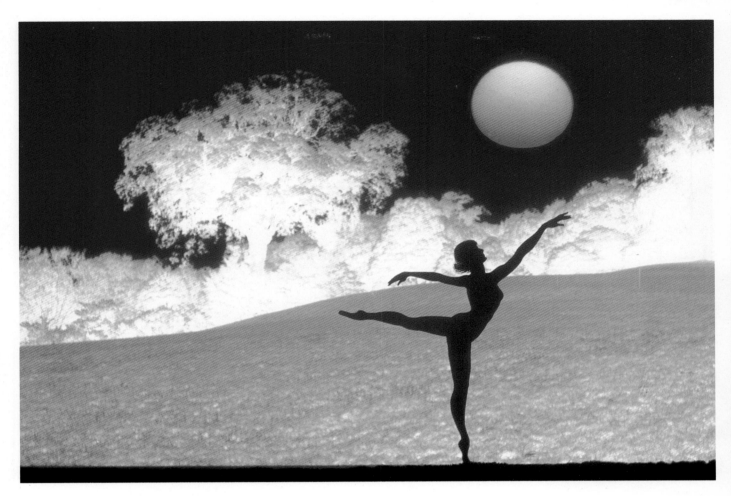

BALLERINA AND PURPLE SKY

Funk had been experimenting with various nude studies when he decided to make this three-part image. First, he photographed a ballet dancer in his studio using a 55mm macro lens. A 12-foot (3.65 m) piece of white seamless backlit with strobes turned the dancer's graceful movement into a silhouette. Funk then decided the ballerina would be more striking contrasted against a landscape, so he located a picture he had made months earlier on an overcast day at George Washington's historical Mount Vernon home. The photo had been shot with a 20mm lens on Ektachrome 64 film through a yellow filter which rendered the gray sky a deep purple. The positive film was processed in negative C-41 chemistry, turning the greenery to magenta, and creating an aura of fantasy.

After sandwiching the two images, Funk still felt that the photograph wasn't quite complete. Searching his files, the photographer found a sunset he had shot with a 500mm Nikon mirror lens, underexposed two *f*-stops so the sky would appear very dark. He rewound the sandwiched film in his camera and double-exposed the sunset in the upper portion of the photo. Suddenly his ballerina was dancing on a poetic outdoor stage instead of in a photographer's studio.

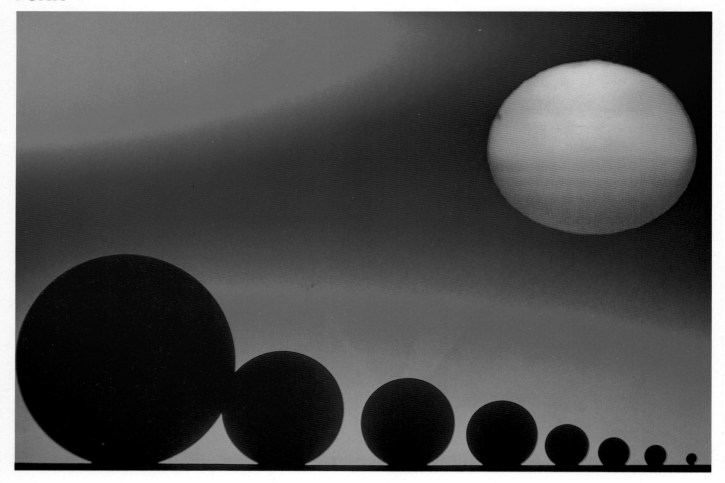

SPHERES AND SUNSET

In this picture Funk wanted to explore the contrasting relationships between very dark shapes and muted lighting effects. With the exception of the sunset, he created the effect entirely in his studio. His first step was to cut out a series of cardboard circles. Using a 55mm lens, he photographed the shapes against white seamless, backlit with strobes to turn the spheres black. To create the modulated glow effects, he covered spotlights with gelatin and aimed them at a piece of green Coloraid paper (a very dense, brilliantly colored material). He then repeated the method using blue paper and a 105mm lens. The blue glow was double-exposed on the green in his copier, and both color effects were sandwiched with the spheres. From his files Funk pulled out a dramatic sun shot taken with a 1000mm lens and double-exposed it in the upper portion of the image. The final photograph, comprised of four separate pictures, became a surrealistic study of shape and luminosity.

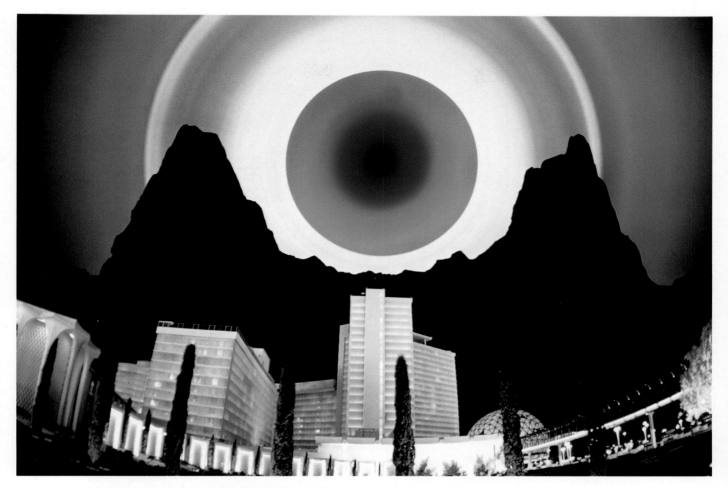

LAS VEGAS SKYLINE, MOUNTAINS, AND SPHERES

To provide this muted color effect, Funk photographed a piece of acetate lit with a 1000-watt halogen lamp using a diffraction filter. Employing a zoom lens with a prism attachment and a time-exposure, he created the impression of moving color. From his files Funk picked out some silhouetted mountains which he sandwiched with a group of seductive, jade-colored Las Vegas hotels photographed with a fisheye lens. He combined mountains, buildings, and glowing circles on Kodachrome 25 film in his copying device to create this cohesive and startling cityscape.

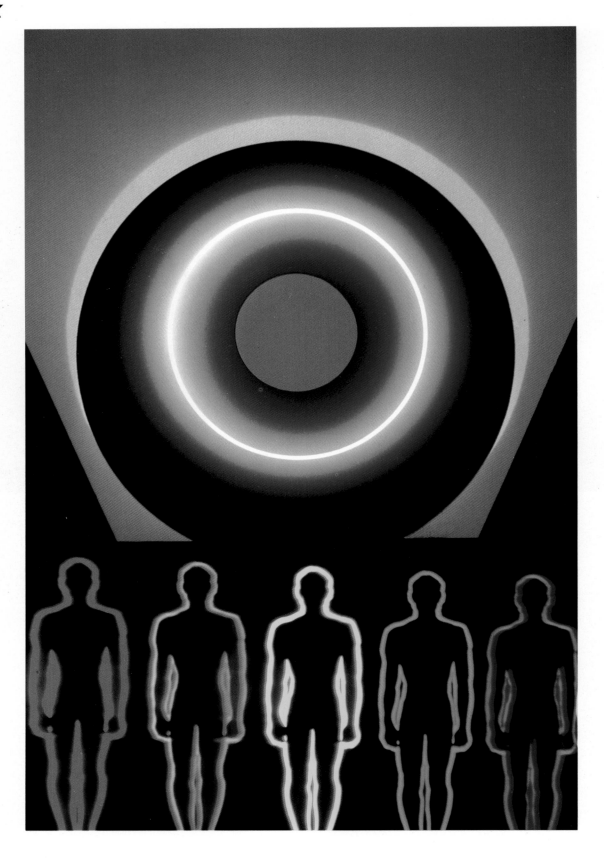

GLOWING MEN AND SPHERE

For this space-age vision, Funk sandwiched five separate images. He used a large, 2000mm sun as the orange background and combined it with a black paper sphere. To create the light blue sphere, he photographed a piece of acetate lit from behind with a 1000-watt halogen lamp, using a blue filter and a soft-focus lens. He then cut a circle in a black piece of paper and photographed it with a red filter to create the red sphere. Lastly, Funk utilized a studio prop of a foot-high man which he photographed five times on the same piece of film, each time using a different colored filter. The images were all combined on the copier to produce this extraordinary image.

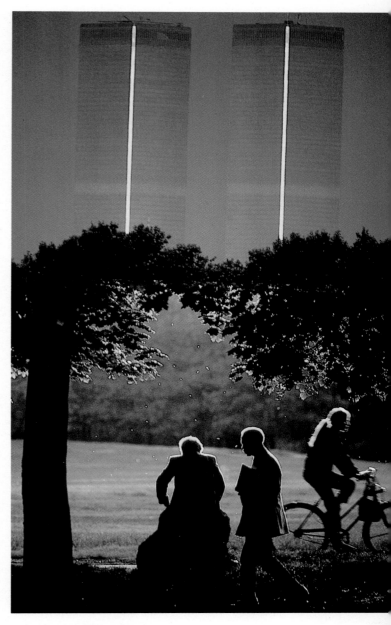

CENTRAL PARK ILLUSION

One evening while strolling in New York's Central Park, Funk spotted a human-interest scene. As the day ended, New Yorkers were out enjoying the last golden-green rays of light filtering through the trees. Using his 200mm lens, Funk exposed a roll of film. A few days later, at dawn rather than dusk, Funk made a trip to a Long Island City cemetery to photograph the World Trade Center from a favorite vantage point. Using the same rewound roll of film, and holding a piece of black cardboard across the bottom section of the frame to preserve his earlier images, he double-exposed the twin buildings rising up above the trees. The late afternoon sunlight and morning haze melded together in an impressionistic twilight study of city light and life.

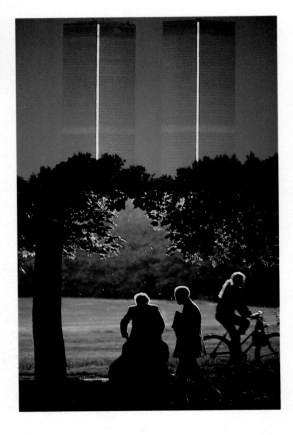

TECHNIQUE
CENTRAL PARK ILLUSION

The two images at top are the basis for the final photograph in which Mitchell Funk places the World Trade Center in Central Park. The bottom photographs show how the sky of the park scene and the foreground of the Twin Towers are blocked out, allowing the two transparencies to be sandwiched together to create this unique urban landscape.

Michael
DE CAMP

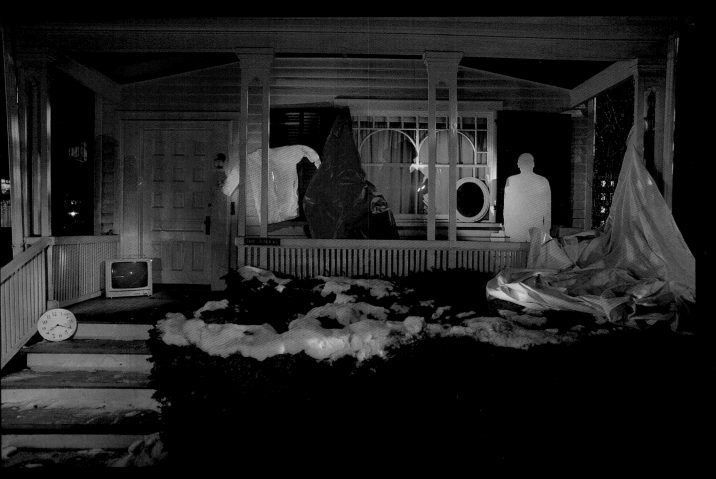

NIGHTTIME FIGURES

To make this bizarre nighttime picture, de Camp first projected light onto a piece of plywood and stood before it to create a silhouette. An assistant drew the lines around his silhouette, and de Camp later cut out the shape.

Various objects were then placed outdoors on a porch while de Camp waited for the sun to set. In the darkness, he opened the shutter of his tripod-mounted Nikon F and began to set off electronic flashes which were covered with various colored filters to produce a multiplicity of hues. Because he couldn't look through the viewfinder to see the effect that was being created, he experimented with a number of long exposures before closing the shutter, varying the placement of the colored flashes.

Michael
DE CAMP

Michael de Camp has been making photographs for twenty years, but he began his career as a nature photographer shooting beneath the surface of the sea. An accomplished professional diver, de Camp has always been interested in the aquatic environment and has worked up and down the eastern seaboard, from Martha's Vineyard to North Carolina, exploring such long-ago shipwrecks as the famous Andrea Doria. He has also made expeditions to the Antarctic to study seals, as well as to tropical waters, and is often busy lecturing on his underwater discoveries.

Although early on de Camp, a self-taught photographer, made pictures of underwater flora and fauna, he yearned to reveal a less familiar terrain. "I graduated from sea to land much as our ancesters did," de Camp jokes. Though the sea still provides a deep blue backdrop for many of his photographs, de Camp now concentrates on making images on land, using as his subject matter carefully arranged found and constructed objects. Unlike many special effects photographers who rely substantially on complicated equipment and intricate techniques, de Camp has a working method that is surprisingly straightforward. Though his photographs communicate an aura of surrealism, his "special" effects are generally created without artificial means; the images themselves do the manipulating, altering the viewer's sense of perspective and scale. De Camp uses natural lighting, a 24mm lens, and Nikon F camera for the majority of his work. But perhaps because of his intimate knowledge of the underwater world, de Camp's photographs possess

an enigmatic quality which seems to suggest the existence of an unknown dimension, a sort of photographic twilight zone where shapes and colors interplay in strange new ways. "I'm very interested in juxtaposing objects to create new arrangements," he explains. "Geometry fascinates me, and making relationships that have never existed before and, in all likelihood, will never exist again in just the same way is what my photography is all about."

In order to build his compositions, de Camp collects various objects that he intuitively feels will one day serve as perfect elements in his odd visual symphonies. Each time he visits a novelty shop or fabric store, he searches for magical plastic shapes, colored geometric bits of glass, or tiny objects he regards as his "toys." Later he takes the objects out and manipulates them to form counterparts to the natural environment. "Just like building a house, these are simply piles of materials until they're put into a certain spacial relationship," de Camp says. "I continue to experiment until I reach the right combination of elements." When he's shooting, de Camp adds, "It's almost like warming up for an athletic event like running." His pictures are the result of a two-part process: knowing his materials and how they relate to each other and being able to make adjustments quickly in order to to arrive at the best possible combination. When the objects don't seem to harmonize, de Camp keeps on experimenting. "If you don't make mistakes, you're not taking risks," de Camp maintains, "and it's the risk that often leads to the best photograph."

The camera is a tool that enables de Camp to express his particular vision. "I think of my photos as landscapes, paintings, or as sculptures as often as I think of them as photographs," states de Camp. Although he has been influenced by the work of the surrealist painter René Magritte and also by Edward Hopper, de Camp claims no specific photographic mentors. Formal artistic concerns have always interested him, but intuition is as much a part of his unique view of the world as is his concern for structure and form.

Perhaps the most extraordinary aspect of de Camp's special effects work is its elegant simplicity. A shell placed in a small hand-built room against a roaring sea and a cloudy blue sky, or an object floating majestically in a mirror of water creates as much visual and graphic allure as the most complicated composite image. For de Camp what one object means to another object is as important as its inherent features; often a subject's ultimate beauty emerges only when its perfect counterpart is found.

A love of diving and underwater life has had an undeniable effect on de Camp, allowing him also to see the everyday above-water world with a different kind of perspective. In de Camp's photographs, objects that are large seem suddenly small; tiny shells and bits of plastic are unexpectedly transformed from the ordinary into shapes of mystery and fascination. Like the most technically advanced special effects artist, de Camp has created a realm of his own, and though it may not appear to be a particularly complicated realm, it is nevertheless defined by this photographer's unique way of seeing. That is a very essential key to what makes de Camp's photographs of ordinary subjects seem so remarkably unfamiliar and surreal.

ABSTRACT REFLECTIONS IN MYLAR

These abstract studies were created by placing plastic shapes on Mylar and experimenting with the arrangements to achieve an interesting series of reflections and shadows. In the first image, a velvet background adds to the mystery by creating a black teardrop shape.

In the second photo, de Camp took advantage of the reflective qualities of the Mylar to duplicate shapes. He then superimposed the image of plastic pieces on a landscape made earlier at Martha's Vineyard to emphasize the distorted sense of scale.

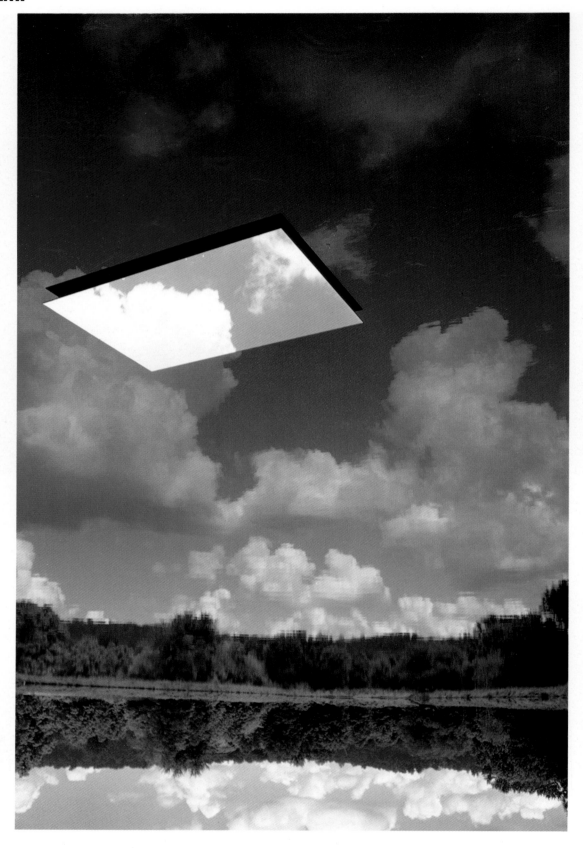

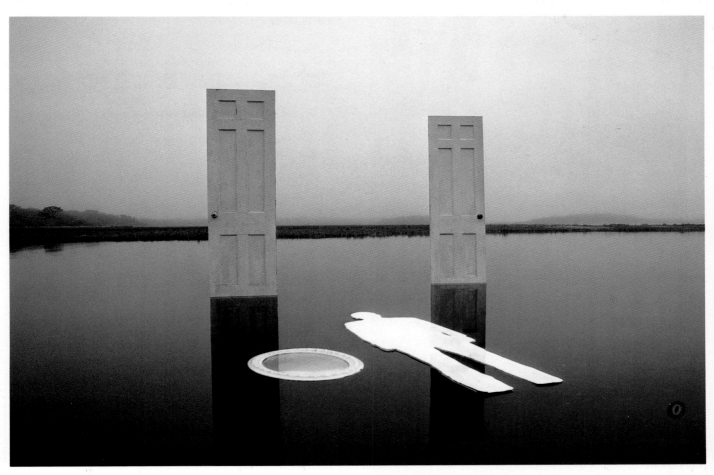

SURREALISTIC DOORWAYS

On a dark day at Martha's Vineyard, de Camp decided to create this surrealistic image. He lowered two doors supported by stakes into a quiet, inlet pond. A life-sized wooden cutout of a man was then floated in the water. Standing knee deep in the water with his Nikon F and 24mm lens, de Camp captured the mysterious serenity of the objects—and of the place.

MIRROR IN THE SKY

De Camp was interested in visually exploring the philosophical idea of opening doors and windows to the universe. De Camp used as the set a pond near Morristown, New Jersey, where he once lived. He placed the objects to be photographed in the clear, still water just at sunrise. The water acted as a mirror reflecting the sky above. In this photograph of the trapezoid, which was actually a mirror floating on Styrofoam, the sky was reflected both upon the object and around it creating a doubly dramatic skyscape/waterscape.

To avoid seeing his own reflection in the water, de Camp photographed at an 80-degree angle using his Nikon F and 24mm lens. This verson also benefited from the added element of the landscape, which, one discovers by turning the picture upside down, is the actual landscape that was reflected in the pond. By presenting this photograph in an unexpected way, the ordinary outdoor scene is substantially altered.

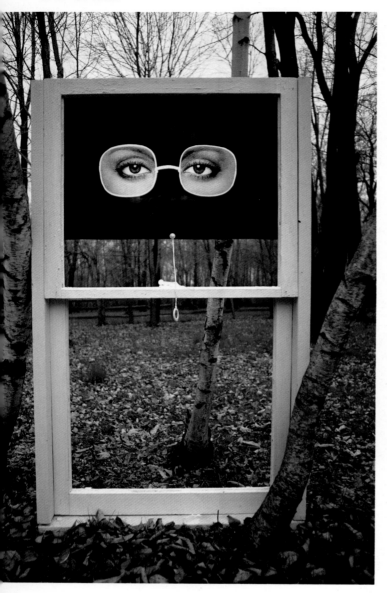

WINDOW IN THE WOODS

For this bizarre view of the suburbs, de Camp placed a glassless window frame with a black shade in his backyard and made a straight shot using his Nikon F and 24mm lens. Leaving the frame in place until dark, de Camp then photographed a pair of blue eyes and glasses cut from a fashion magazine. He replaced the black shade with a white one, and in the darkness, projected a slide of the "framed" eyes onto the white area. He rewound the film in his camera and made a second exposure capturing the projected image on his original daytime scene.

CLOCK IN THE SKY

At a pond near Morristown, New Jersey, de Camp combined man-made and natural elements to make this unusual photograph. The clock was attached to a piece of Styrofoam and gently placed in the water. He then shot the scene using the reflective qualities of the water to capture the background landscape. De Camp then printed the picture upside down for an even more dramatic effect.

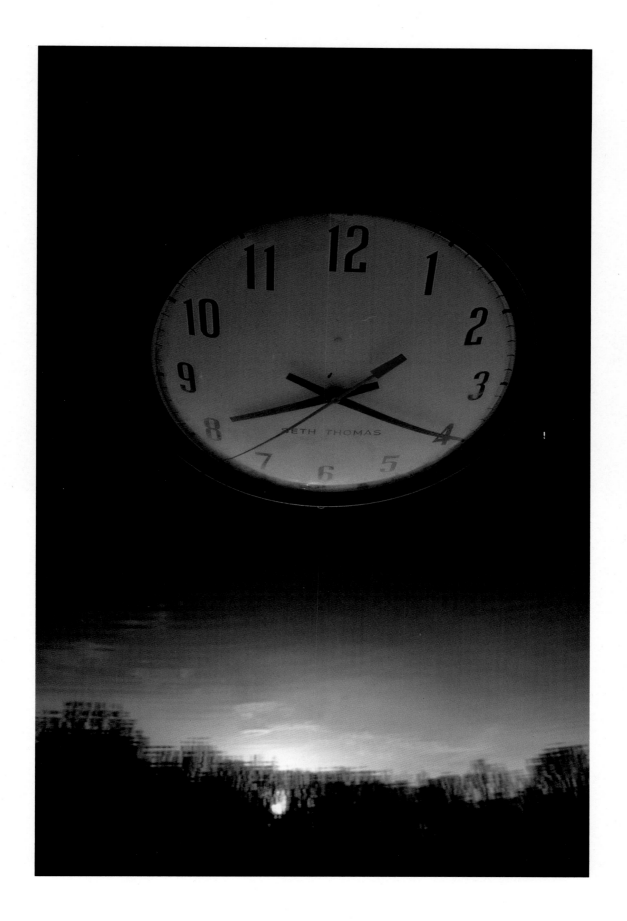

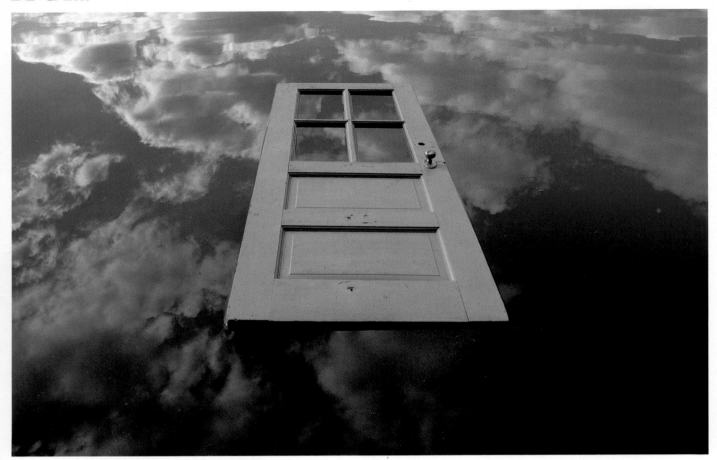

DOORWAY TO THE UNIVERSE

At the same pond in New Jersey, de Camp created another visual interpretation of a philosophical doorway. He floated a door on the calm water of the pond and positioned himself on the bank. He photographed the scene, using his Nikon F and 24mm lens, at an angle that would prevent his own reflection from interfering with the scene.

With the stillness of the pond acting as a mirror reflecting the clouds from the sky, the illusion of a doorway to the universe is complete.

CUBES WITH MARBLES

To create this finely balanced study of spheres and squares, de Camp placed a croquet ball, painted white, in a plastic cube which rested on another cube that had been filled with crystal marbles. He shot the scene set against a blue sky using natural light and a pristine, white wooden foreground. Although the objects were no more than several inches large, the resulting image creates an illusion of depth. The reflective plastic cubes intensify the appearance of dimension and provide a delicate secondary study of line and structure.

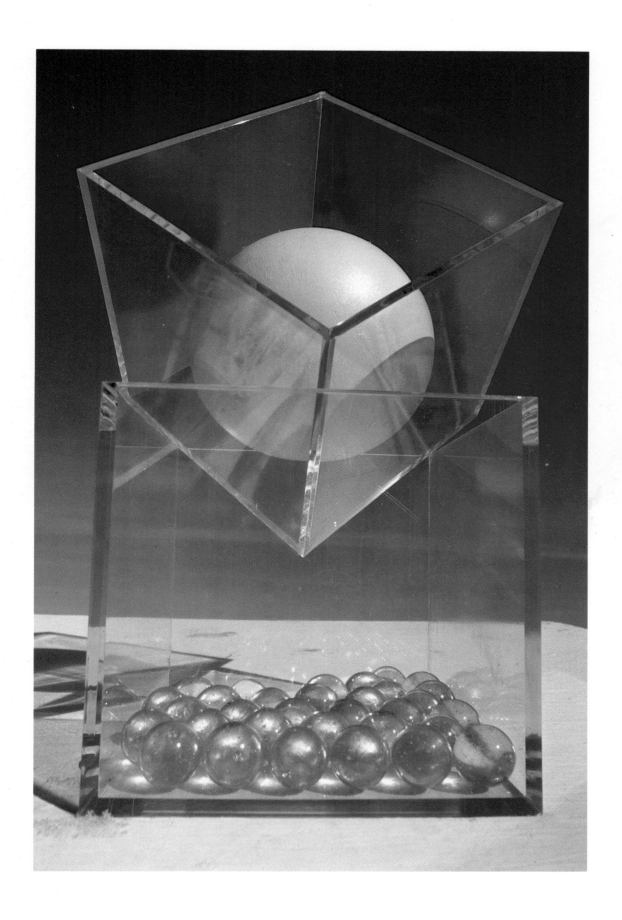

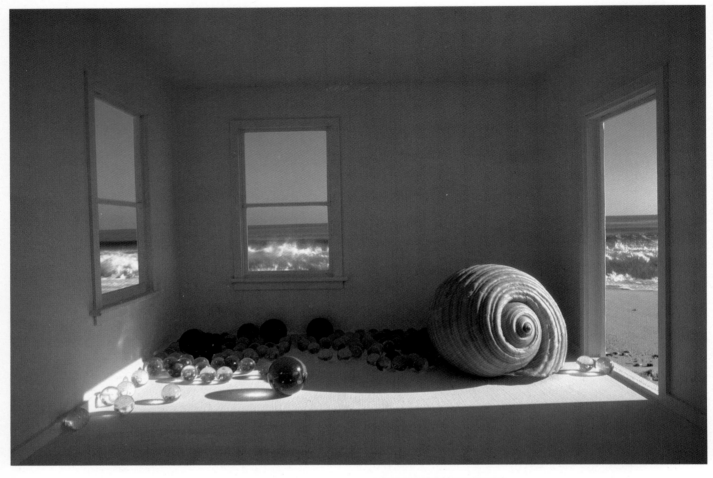

SHELL WITH MARBLES

As with the following three images, de Camp used the same basic set, each time modifying the composition slightly to create vastly different moods. De Camp first built an 18-inch-wide by 18-inch-deep (45.72 × 45.72 cm) plywood room, leaving one side completely open and using miniature windows in the remaining walls. The room was placed on a tripod with the objects positioned inside it. De Camp could shoot either through the windows or through the open side as the composition required.

The two sea images were shot at the New Jersey shore using the water as a natural background. In the first image, a shell and marbles were positioned so the bright sunlight, which streamed in from the right, would highlight the objects and create interesting shadow effects.

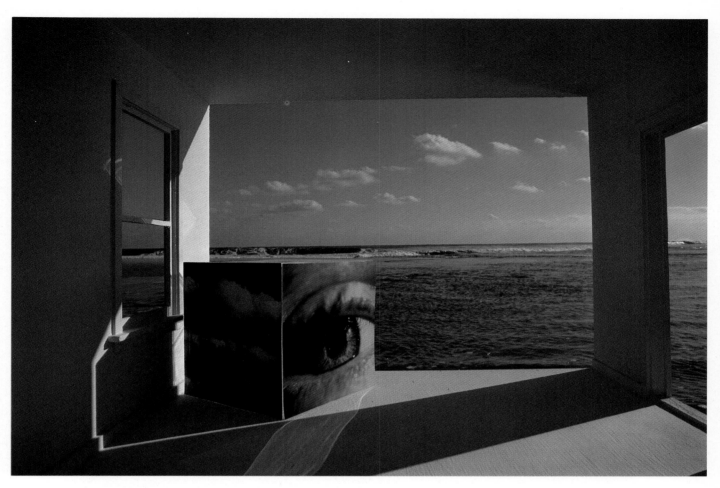

CUBE WITH EYE

De Camp then turned the room and positioned a cube in one corner. On the cube, he had pasted Cibachrome prints of clouds and his wife's eye—which he had shot with a 24mm lens. This provided a surrealistic impression. Once again the sea provided the backdrop, and natural light was utilized to its fullest to create odd swatches of illumination.

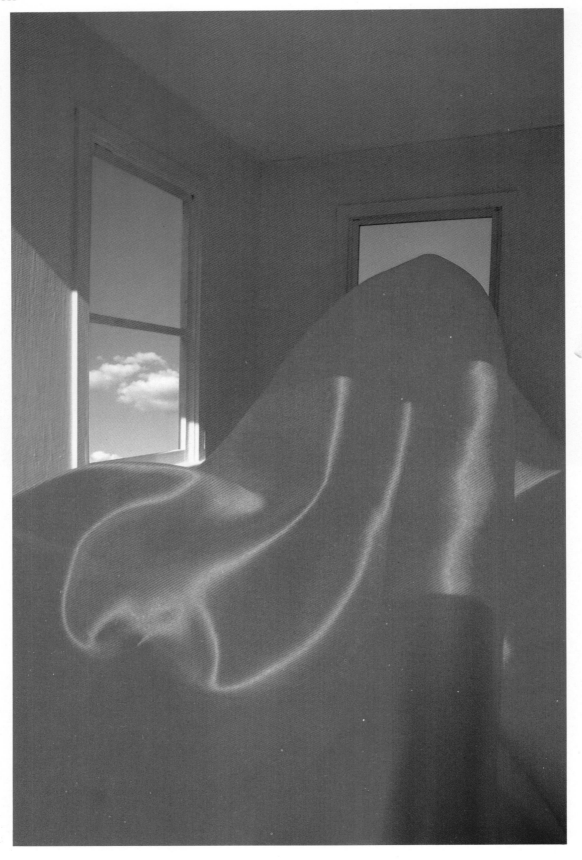

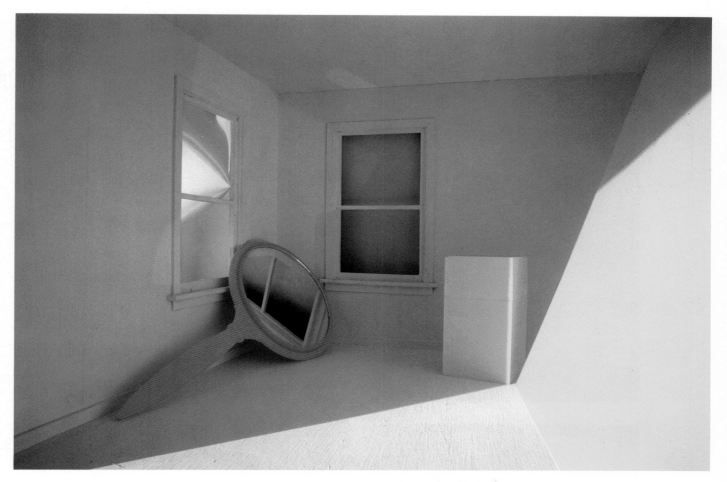

MIRROR AND PLASTIC

In this image, he used a small mirror and plastic shapes, which made the walls appear yellow. He lit the "indoor" set with a tungsten bulb and covered the windows with white cloths. The results indicate that a wide variety of tones can be achieved by using a single, flexible prop. The photos also illustrate de Camp's mastery of controlling sunlight and shadow to enhance the beauty of a world within a small room.

SATIN CLOTH

In this image, the room is not used to distort the perception of scale, but rather to color the final image. Since the walls in the room are white, they pick up the color of the objects placed within the room. In this photograph, De Camp placed a remnant of satin in the room creating an overall illusion of pink.

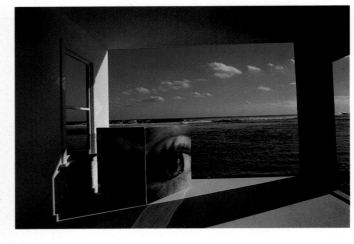

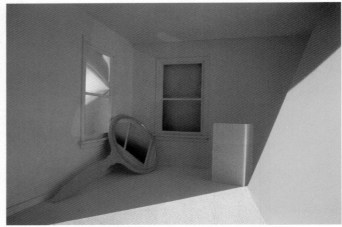

TECHNIQUE
CUBE WITH EYE, MIRROR AND PLASTIC

Michael de Camp uses many props to create his surrealistic views, which are often placed in the small room that serves as the set for his outdoor studio. The flexible nature of this miniature set allows de Camp to place it in any environment, taking advantage of the view as well as the lighting conditions.

These photographs show how de Camp will combine backgrounds and materials to create a number of variations on the same theme. For example, while the first background shot (*top left*) shows many of the props used in his images, *Cube with Eye* (*top right*) was actually taken at the beach, in a similar manner as that shown by the second background shot (*bottom left*).

CUMMINS

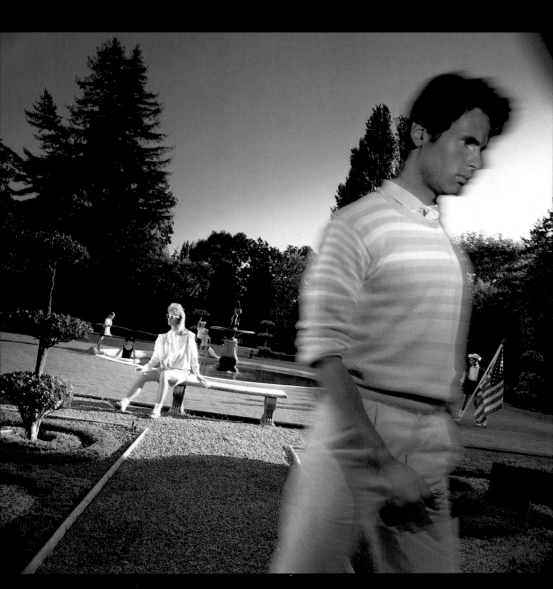

MODELS AND MANNEQUINS IN GARDEN

The theme for the Spring '83 Generra Sportswear campaign involved interspersing real models with mannequins, and the effect was further strengthened in this image by a blonde model in the background who posed as if she were one of the dolls. To accentuate the surreal illusion and balance the static pose of the background models, Cummins asked the foreground male model to move while he shot with a Hasselblad 2¼"-square and 50mm lens, using a

Norman 200B strobe with a small reflector. Selecting a slow shutter speed of about 1/15th second combined with a flash, Cummins recorded the blur of the model's movement as well as the crisp strobe image. As the model walked forward after the flash, light was subtracted from the sky exposure, creating a darker area surrounding his silhouette. A strange modulation of light in the upper left hand corner was created by a graduated blue-density filter.

Jim
CUMMINS

Jim Cummins, who runs a commercial studio in Seattle, began making pictures while he was at Occidental College in Los Angeles in the early 1970s. Although his major was psychology, Cummins soon found that he'd rather read about Type C prints than Type B people. When he graduated, he decided to devote himself to studying how photographers, rather than researchers, view the world. While struggling to find a voice as an art photographer, his first job was as a medical photographer at the University of Washington in Seattle. While making photographic records for the medical staff, he became increasingly interested in the technical aspects of the medium.

It wasn't long before he became enthralled by the commercial applications of photography as well, and in 1975 he decided to become a freelance photographer. "I was so naive about the field that I didn't even know that I didn't know enough to do it," he recalls. "I just went out and started getting assignments." But his naiveté was mixed with a strong measure of determination and an overwhelming curiosity about what the vast world of photography might offer. On a visit to New York City, Cummins spent two days assisting special effects master Michel Tcherevkoff. Though Cummins had previously been shooting primarily architectural and interior design photos, the experience—short but significant— opened his eyes to the many possibilities of advertising photography, and he

returned to Seattle to pursue his new fascination.

Cummins soon established himself as a professional photographer shooting for such accounts as The Gap, Pacific Northwest Bell, Microsoft, Hewlett Packard, Olympic Stain, and Generra Sportswear. Although much of his work involves "straight" photography, Cummins enjoys using special effects to meet his clients' requirements. "The way I got into using special effects," Cummins admits, "is probably different than most New York photographers. Rather than having to convince clients to hire me by showing samples similar to what they needed, they often asked me for effects beyond what I'd previously done, but because of my technical background from medical photography and the studying I had done on my own, I knew what to do."

Perhaps his most successful special effects work has been for Generra, whom he began working for in 1982. He was recommended to the company's advertising agency, Edelstein & Associates, by designers with whom he had worked. Generra has a highly conceptual approach to its clothing, and Cummins was called upon to ensure that the photographic methods used would blend with the innovative spirit of the product. Usually, Cummins explains, the Generra advertising themes evolve as he discusses the collection of clothes with designers and art directors. At these brain-storming sessions, Cummins and his client decide upon the kind of mood he must create to clarify the image of the clothes. Often, Generra's expertly produced and designed brochures are created in only a few weeks time, so Cummins goes straight to work turning the concepts into photographic realities.

Although Cummins shoots for a variety of clients, his fashion work is particularly illustrative of his special effects virtuosity. Silhouettes, dark shadows, highlighted colors, or romantic "fogged" images suggest the comfort and style of the clothing. Unlike the graphic, high tech appeal of many special effects images, Cummins's pictures possess a rhythmic flow and delicate sense of mood. "Generra is interested in feelings," Cummins explains, and he has found that special effects methods work best to express those feelings.

Cummins shoots both on location and in his studio, often using a combination of grid spotlights and a continuous quartz light source to create his impressionistic scenarios. He also has experimented successfully with special effects at the enlarging stage, creating hazy reveries, turning shadows into startling bursts of color, or adding finely textured grain to combine and blend images that were shot at various sessions. Whatever method Cummins employs, he is always seeking to combine beauty with technique, satisfying his own high artistic standards along with his clients' needs.

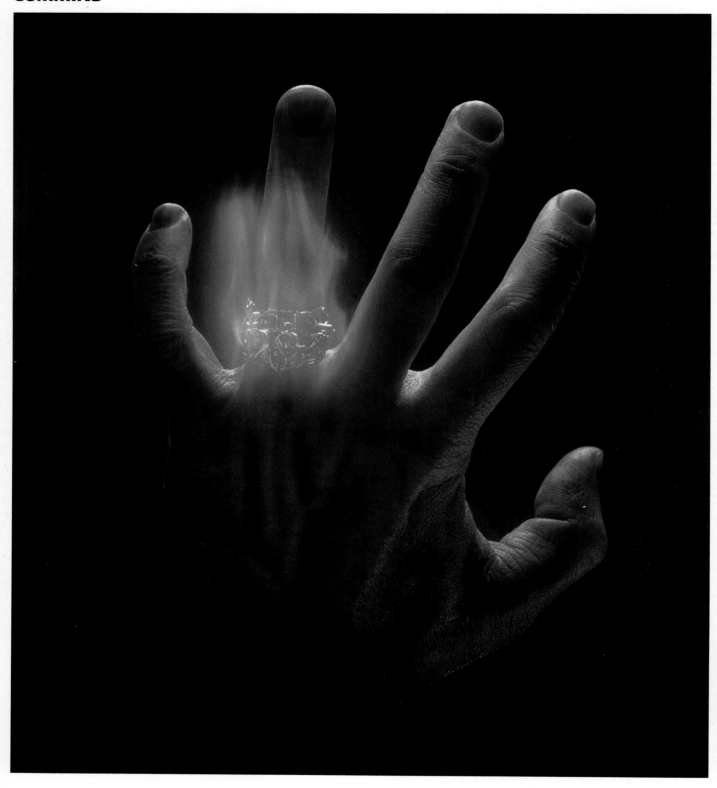

THE RING

For the Seattle Opera's poster advertising its production of "The Ring," Cummins used a double exposure to create this startling effect. A ringed model's hand was made up to appear gnarled and gritty, and then photographed against a grayish-green background with an 8 × 10 camera and 360mm lens. The camera was then pivoted to another set.

On the same sheet of film, Cummins then shot a piece of black sewer pipe that had been cut into the same shape as the ring and suspended in a black set. Since the pipe was placed farther away from the camera, in order to appear on film to be the same size as the ring on the model's finger, refocusing was necessary. The pipe was coated with rubber cement thinner and lit to provide a fiery burst that was captured during the one-half-second exposure. Using the larger prop allowed Cummins to create this dramatic flame rather than a tiny candlelight.

RAINDROP DANCERS

To publicize "Seattle Discovers Dance" for the Dance Advisory Council, Cummins was asked to create a photograph that involved both dance and water—appropriate partners for an arts-oriented city located on Puget Sound. Positioning the rail and the standards of his view camera vertically, Cummins clamped his 35mm Canon F1 to the stand and attached a bellows to the camera body. Using an extension ring on his 100mm macro lens, he created magnification ratio of 2:1. He then positioned a photo he'd made of a dancer during an earlier assignment at the lower end of the stand, parallel with the camera. Between the camera and print, Cummins attached a one-half-inch-square (3.2 cm sq.) glass slide sprayed with glycerine and water. The beads of moisture that formed acted as tiny lenses reflecting the dancer. At f/32, Cummins photographed the water droplets using two light heads from a Norman 2000 D system placed above on either side of the slide. The final image revealed an exciting visual encore.

CUMMINS

BLUE STAR-STREAKS

When he was commissioned to shoot an annual report cover for Rockcor, Inc., Cummins wanted to create a photograph that suggested the company's involvement in space and fiberoptics. He cut circles in a piece of black velvet and placed a continuous quartz light source behind it. Shooting with a 4 × 5 camera and 65mm lens covered with a fog filter, Cummins created this vision of stars during a thirty-second exposure. The camera was mounted on a motion picture tripod with a long handle attached to the tripod head to provide leverage and ensure a fluid movement. As a metronome ticked off the seconds, Cummins moved the tripod head, checking the camera position at predetermined points to create the illusion of star light in motion. He then transported the film to a 4 × 5 camera on another set, and double-exposed the pink background stars.

THREE MODELS

Generra's Fall '84 fashion line concentrated on dark colors, so Cummins produced a set of mysterious images to complement the somber shades of the clothing. Cummins posed the models against a white cyclorama and shot with a 35mm Canon and 50mm lens. To light the models, he used grid spotlights—a honeycomblike metal sandwiched over a strobe light source connected to a high-powered generator. A small-slat blind placed before a continuous 1000W quartz spotlight produced subtle stripes of dark and light in the winglike shape in the background.

As the models moved between the camera and the continuous light shining on the background, light was subtracted from the background and recorded as blurred shadows. The stationary model remained in darkness during the quartz exposure, so no blur is seen. The difference between shooting with combined strobe and quartz light rather than just the strobe, Cummins explains, is that while the strobe exposure is instantaneous, the quartz light builds up brightness during the entire time the shutter is open. If a subject moves, a dark track will register on the film in the area the subject moves into after the strobe exposure. At the same time, if the background is bright enough, the area the subject vacates will "burn through" the strobe image.

WOMAN IN YELLOW SWEATER

Cummins photographed this intriguing lady on Ektachrome 100 with a Hasselblad 2¼"-square and 150mm lens. A four-foot (1.22 m) softbox suspended over the lens, a grid spot placed on the left side, and two reflectors each placed at a 45-degree angle to the white background provided the lighting. An internegative was then made of the best frame. Cummins projected the internegative in an enlarger with a fog filter over the enlarging lens to produce a hazy, romantic effect on the Type C print. By placing a fog filter over the enlarging lens, the dark areas of the subject are fogged. A relatively common process in black-and-white fine art photography, Cummins discovered that in color, this "fogging" effect is even more alluring.

FASHION COUPLE

This photograph, actually a combination of two pictures from separate modeling sessions, was produced for the Generra Sportswear Fall '85 catalogue. Cummins shot a series of images with a Hasselblad 2¼"-square using 80mm and 150mm lenses and Ektachrome 64 film. The models posed against a white cyclorama that was highlighted with reflector cards placed at 45-degree angles.

The photos were then edited on a light box by overlapping transparencies to achieve a unique effect. The challenge was then to combine the two images on one sheet of paper without excluding essential elements or creating excessive areas of density. Cummins projected the shots and traced the outlines of the desired forms on a single piece of paper. Because the sizing on this series wasn't always precisely the same, appropriate magnification was then determined and internegatives were made. To add a consistent texture to this particular image and others in the catalogue, grain was then provided by contact printing tracing paper onto an additional negative.

Since some of the photos were combinations of three to four shots of varying magnification, this step ensured a harmonious grain throughout the brochure. In this particular image, Cummins used his "fogging" technique when he enlarged the negative of the male subject, but the female model was sharply printed.

FOGGED CHAIRS

These "fogged" chairs, shot for Generra, were placed on a white cyclorama and photographed with Vericolor negative film, using a Sinar camera with 150mm lens. The clothes were padded with paper and positioned to create a window-display impression. A combination of overall room illumination provided by strobes bounced off the ceiling and grid spotlights placed to the photographer's right was used.

An internegative of the image was then produced, and the light path from the enlarger to the Type C print was recorded using a diffusion filter which created the "fog" effect and obscured the sharpness of the lighting. The result: cleverly haunting stuffed shirts.

POSTERIZED TORSOS

For a Generra assignment in 1983, Cummins wanted to show the clothing in a detailed but eye-catching manner. For the images shown here and on the following pages, Cummins started with straight photos of the three torsos. Using a 4 × 5 camera and 210mm lens, he photographed the models against orange, yellow, and violet backgrounds enhanced with colored gels. The 4 × 5 transparencies were then taken to a lab where litho negatives of the image were made. On the litho film, the black shadow areas appeared clear. These clear areas of litho film were then opaqued with a brush to protect certain black areas from the color that would later be added.

An 8 × 10 composite duplicate was then made by combining both of the previously created images. The first exposure utilized a contrast reduction mask (a low-contrast, black-and-white negative, with added density in the highlights) sandwiched with the 4 × 5 original. Then a sandwich consisting of the opaqued high-contrast litho negative and a gel was exposed to produce the brightly colored shadow areas. A pin-register enlarging system was necessary to ensure precise alignment of the sharp-edged shadows.

POSTERIZED TORSOS

These examples of Cummins' posterization technique, which is described in the caption on page 61, show how special effects can be used with dynamic results in such fields as fashion photography. The clothing is effectively displayed, while the high-contrast colors in place of shadows act as magical photographic magnets.

CUMMINS

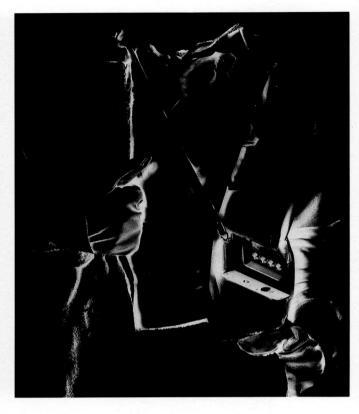

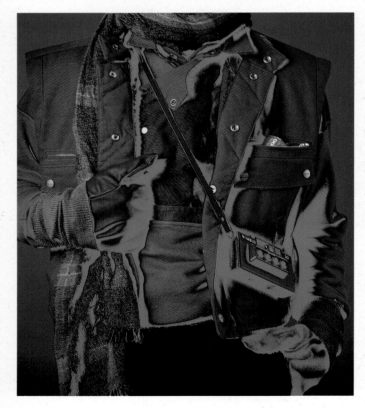

TECHNIQUE
POSTERIZED TORSOS

Jim Cummins begins the posterization process with a straight fashion photograph, in this instance the torso (*upper left*). The image is then copied onto lithographic film (*upper right*), with specific areas opaqued to allow for the addition of color. The lithographic film is then exposed again, with a colored gel over the shadow areas, as a composite with the original transparency.

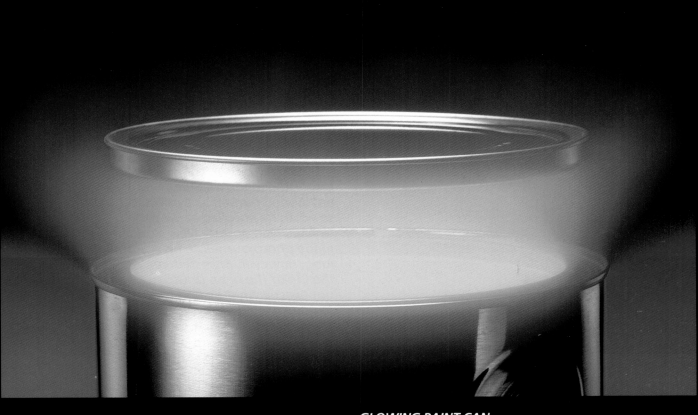

Steve BRONSTEIN

GLOWING PAINT CAN

For this Rohm and Haas ad, Bronstein wanted to create the illusion of energy emerging from a paint can. Suspending the cover above the can, he cut out the bottom of the can and placed an orange-gelled strobe inside. Dry ice fog was then pumped up into the bottom of the can. When the room was filled with colored fog, Bronstein popped the strobe beneath the can to register the light coming up through it. To create a clear image of the exterior of the can, he made a second exposure, without the fog, against neutral Plexiglas. The photo was shot with an 8 × 10 Arca Swiss camera and a 14-inch lens. The double exposure ensured that both the can and the fogged light would register dramatically on the film to create this luminescent impression of floating color.

Steve
BRONSTEIN

Philadelphia-born Steve Bronstein did not intend to become a still life photographer with a flair for special effects. Though he was always interested in the medium, Bronstein envisioned himself as a photojournalist, so when he enrolled at Syracuse University in upstate New York, he made photojournalism his major. Before long, however, Bronstein realized that the life of the news photographer was not exactly what he had expected. "It seemed like I'd always be running around harrassing people, trying to end up in the right place at the right time," he says. Bronstein decided he'd rather be placing elegant objects in the right position at the right moment, so he switched to still life photography and after graduation worked as an assistant. In 1978 he landed a job as an assistant to photographer Steve Steigman.

His assistantship grew into a lasting commitment, and with Steigman and Howard Berman he became involved in the formation of Big City Productions, a large Manhattan-based studio where the three photographers work with advertising agencies and design firms on both still photography and film production. "Rather than going to different people for different needs," Bronstein explains, "we thought it would be better for the clients, and the reps, to have everyone under one roof." With a total of about thirty people on staff, "we have a lot of hands—and heads—to call upon whenever there's a problem that needs to be solved."

Although Bronstein doesn't consider

himself to be a special effects photographer per se, he nevertheless uses unique methods whenever necessary to achieve his photographic goals. "Special effects shouldn't be used indiscriminately, but only to answer specific problems," Bronstein explains, "and my objective is to do as much as possible in-camera." Knowing when to use special effects and when to resort to retouching or stripping, says Bronstein, simply comes from experience. "The key to success in a lot of assignments is having the time to experiment and work out your problems," Bronstein maintains. "Special effects may take longer than most shots—perhaps a day or even two." That doesn't seem like much time, but to the professional photographer working against a demanding deadline it's about the maximum that can often be afforded.

Bronstein has a worldly attitude about the business of photography which he attributes to working so closely with his successful colleague Steigman. And Bronstein's professionalism is appreciated by such clients as Sony, Toshiba, AT&T, and Absolut Vodka, for whom he has created a comprehensive series of ads. Although Bronstein's accounts cover a wide range, each client has one common purpose: a desire to explicitly reveal their products' best points through the use of a sophisticated yet understandable visual vocabulary.

Bronstein claims no direct influences on his work, though like most still life photographers, he admires "the look of the big view camera at its best—such as Phil Marco." He has developed his technique primarily independently, and his pictures are clearly the result of a perfectionist's mind and methods. Characteristically, his photos are pristinely lit, with a low-key use of color and a high sense of visual logic. In all of Bronstein's photographs—whether of a Dantesque-looking telephone, an incongruously placed sky-sign, or a glowing paint can—each element is carefully arranged or constructed in an elegant, skillful manner. Though his use of special effects is subtle, Bronstein has a rare talent for delicately building an ordinary set of objects into an extraordinary orchestration of lighting and props.

Still life photographs can often be almost annoyingly unrealistic, making everyday products seem too good to be true. In Bronstein's images reality is askew, but only slightly. Water streams miraculously, an ice cube harbors a seductive blonde, or a glass of vodka creates a visual echo. Things may not be what they seem at first, but strangely, they are always somehow plausible. Bronstein may believe in the classic still life credo—the large format camera, meticulous lighting, and visual balance—but there's a wry imagination and a twist of whimsy at the heart of his work. Perhaps a bit of the photo-journalist's daring has slipped into this still life artist's methods. He may not always be in the right place at the right time, but Bronstein's photographs certainly do have the right stuff.

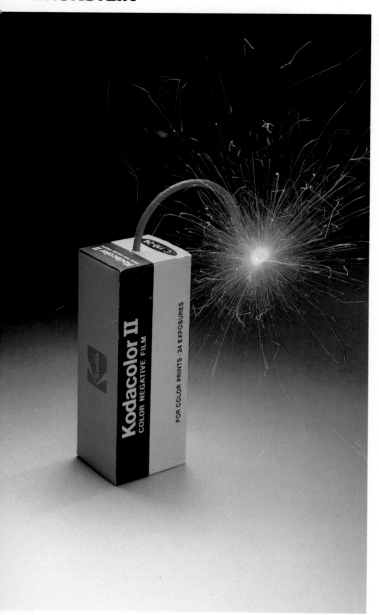

KODAK FILM FOR THE HOLIDAY

Putting a little sparkle into this ad for Kodak film presented a unique challenge: how to make the shot without sparks damaging the film box. Bronstein solved the dilemma with a double-exposure approach. On a gray seamless he photographed the film box and fuse, using an 8 × 10 camera. Then, with a second camera, Bronstein shot straight down on a lit sparkler set against a black background. He then marked the position on the ground glass and double-exposed the sparkler, using a neutral density mask so that the light of the sparkler wouldn't wash out the box. On the final photo, sparks flying across the box were retouched out in order to maintain a clear image of the product.

NUDE IN AN ICE CUBE

Bronstein made this sample shot as a commentary on subliminal advertising. First, he photographed the nude model against white seamless, using a 2¼"-square Hasselblad. He burned out the background of the image to create a transparent surface. A model maker then made a plastic ice cube, sawed it in half, and polished it so that bumps wouldn't cause a distortion of the image that was to be placed inside. The transparency of the model was glued into the cube, which was then wired from behind directly into the neutral-density Plexiglas background. While a hand model maintained a stationary position, a special device dropped the second ice cube down a shoot into the whisky-colored liquid to create a splash. Bronstein used a timing device to trigger the flash each time the cube was dropped. The image was shot with an 8 × 10 Arca Swiss camera and 14-inch lens. The delicate, transparent effect of the woman in the cube makes Bronstein's commentary "crystal clear."

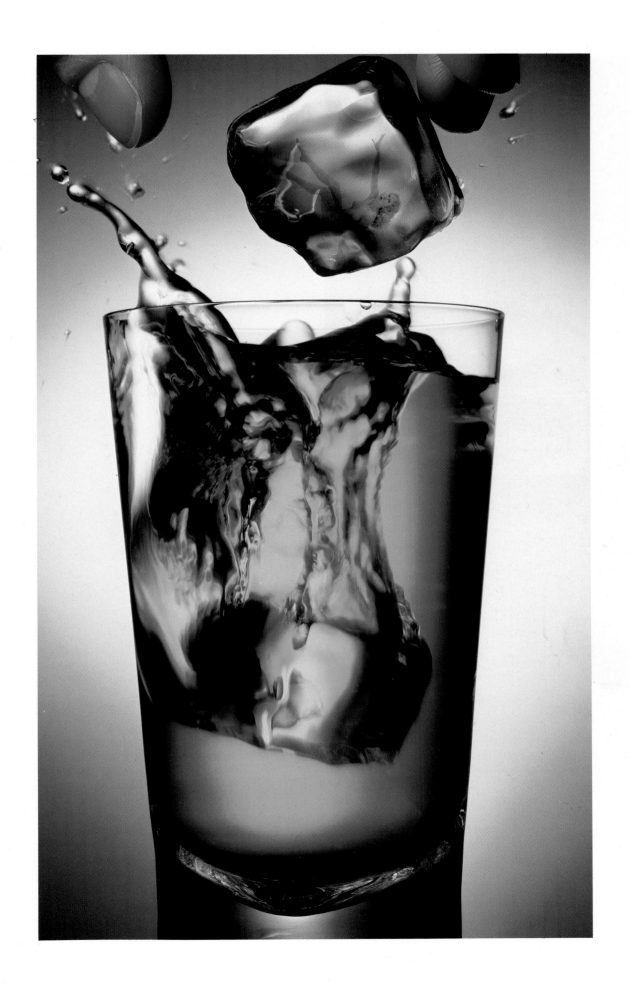

BRONSTEIN

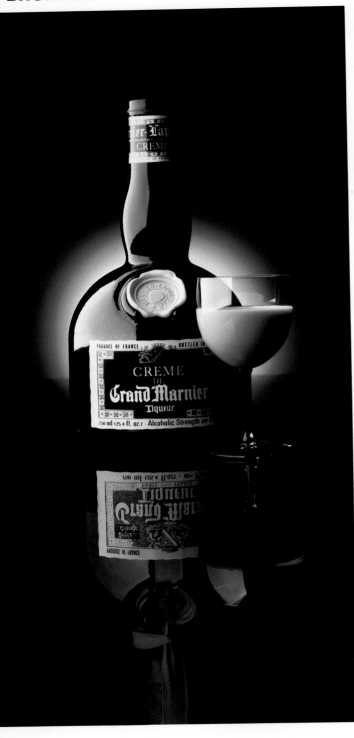

GRAND MARNIER REFLECTIONS

This photo of cream Grand Marnier reflecting into regular Grand Marnier liqueur is typical of Bronstein's low-key, second-glance style of imagery. In one camera Bronstein shot the cream Grand Marnier bottle and glass, using a black card cutout in the 8 × 10 camera to mask the contour of the bottom bottle and glass. With the other camera he followed the same masking procedure, but the second time shot what would become the reflection. The shot was lit with a 30-inch-square (76.20 cm sq) bank light, and neutral gray sand-basted Plexiglas provided the background. The two images were then combined to create a grand double-Marnier vision.

ABSOLUT VODKA WITH GLASS ILLUSION

Bronstein had been working on a series of ads for Absolut Vodka when he made this attractive, "moving" still life. He backlit the bottle against sand-blasted neutral gray Plexiglas to create a soft glow, but he frontlit a shiny black cardboard base surface to provide a slightly blue cast. The "four-part" glass on the left, of course, is the key to this photograph's appeal. After shooting the bottle and an upright glass with an 8 × 10 Arca Swiss camera, Bronstein had three of the elegant glasses expertly bent by a model maker. He then arranged the three glasses on a notched turntable and set up another view camera. Bronstein rotated the turntable one-third of an arc until the next glass fell perfectly into position to achieve the proper alignment each time he made an exposure. The notched turntable enabled Bronstein to lock the glasses into precise position while a black card was used to mask out the base of each of the glasses. Finally, Bronstein double-exposed the progression of glasses on the first image of the bottle and upright stem. The result: an absolutely classy glass menagerie.

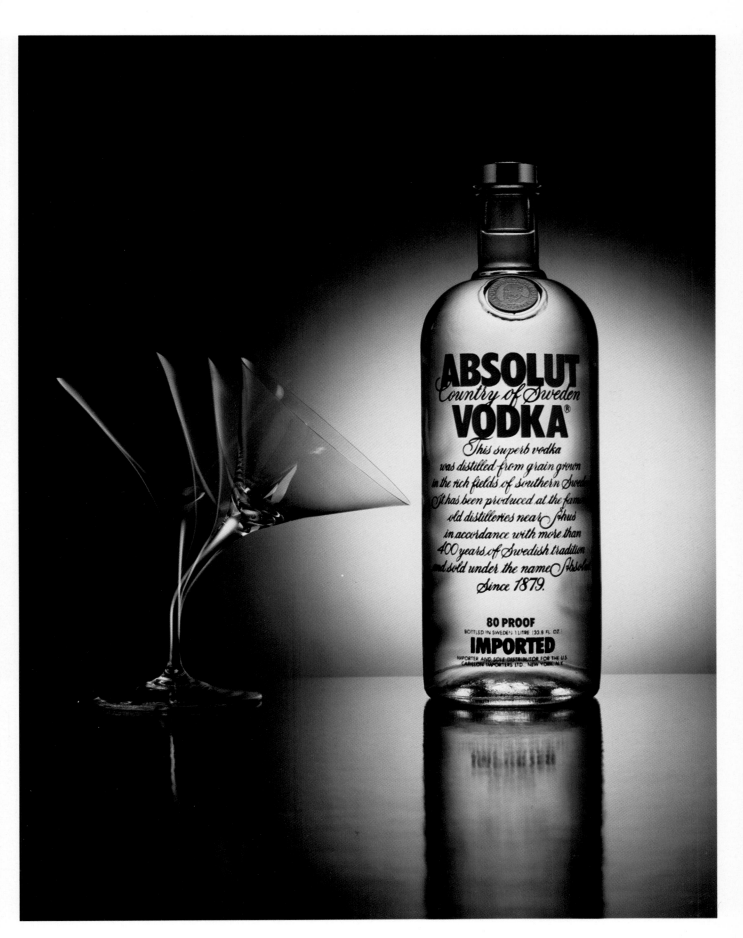

FLOATING SIGN

To create this heavenly roadway for Atlantic Aviation,
Bronstein obtained a stock transparency of clouds
from photographer Jay Maisel, which was made into
a Duratran, a large display transparency. A model
maker provided the sign, which was placed on a
frame rigged with wire and angled independently of
the backdrop. Bronstein backlit the Duratran and
frontlit the sign. He used fluffed bits of cotton placed
close to the camera to create the out-of-focus clouds.
With dry ice fog and a bit of diffusion, Bronstein shot
his space highway with an 8 × 10 camera and wide-
angle lens.

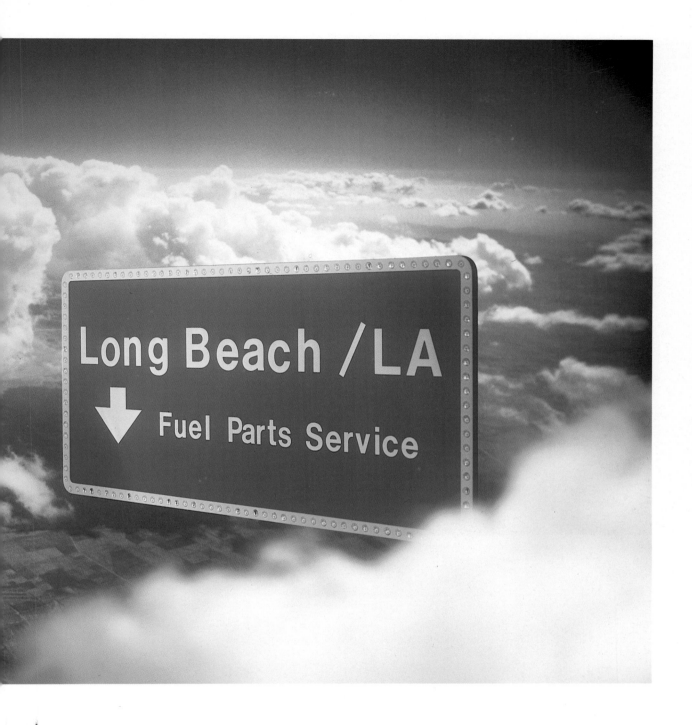

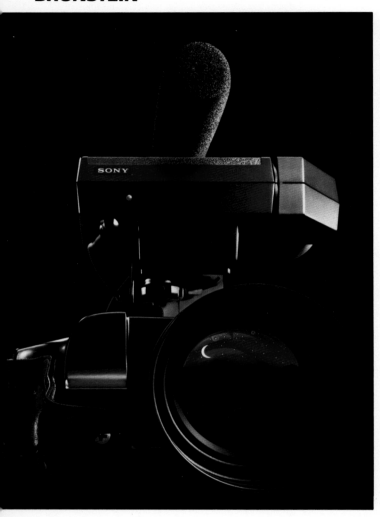

VIDEO CAMERA AT NIGHT

For a Sony ad for a camera that operates in the dark, Bronstein placed the product on a black background and lit it with blue highlights and kick lights to provide a nighttime feeling. He shot the set with a 4 × 5 camera and 90mm lens. The photographer then commissioned a 3 by 4-foot (0.91 × 1.22 m) painted backdrop of mountains and a moon. He took a standard magnifying lens out of its holder, positioned the glass to reflect the painted backdrop image, and made an exposure. The reflection was then double-exposed on the camera shot to provide a romantic vision of a practical invention.

TELEPHONE LANDSCAPE

Originally shot for Western Electric, Bronstein commissioned a backdrop painter to create an "otherworldly kind of Grand Canyon." The seemingly cracked terrain was constructed from pieces of broken Plexiglas, carefully arranged and spaced. Red-gelled lights were placed beneath the material to provide the strange illumination. The phone was positioned on a base slightly above the Plexiglas to provide a floating effect, and the hand set was rigged with interior lights. Dry ice smoke was blown over the set to create a dreamlike blanket of fog. The photo was achieved with two exposures—one with strobe light and one with tungsten light to capture the telephone's glow. Both were shot with an 8 × 10 camera and 165mm lens.

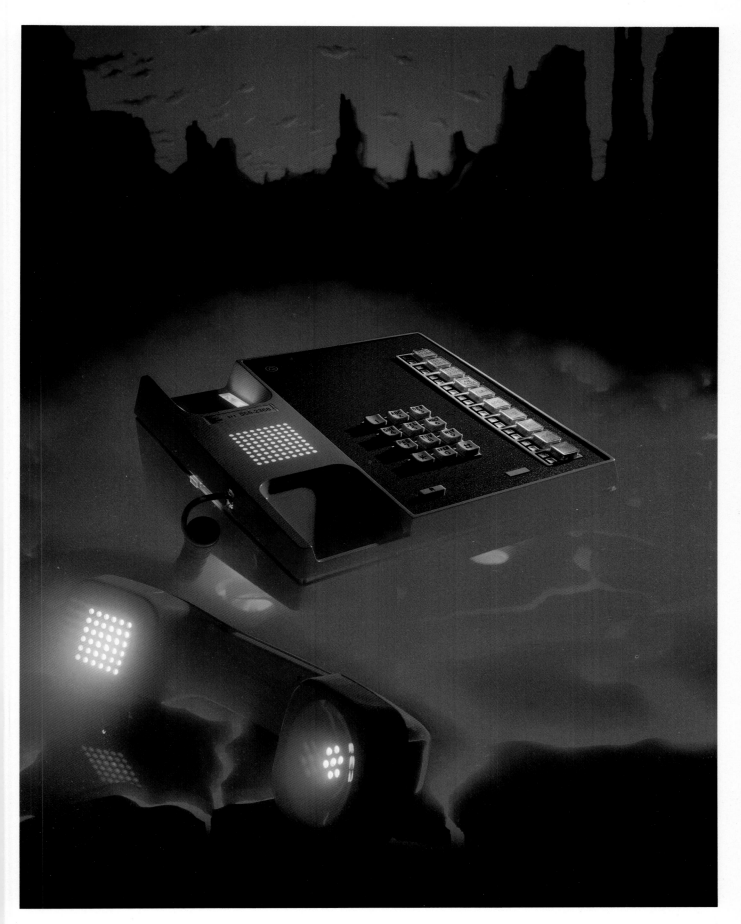

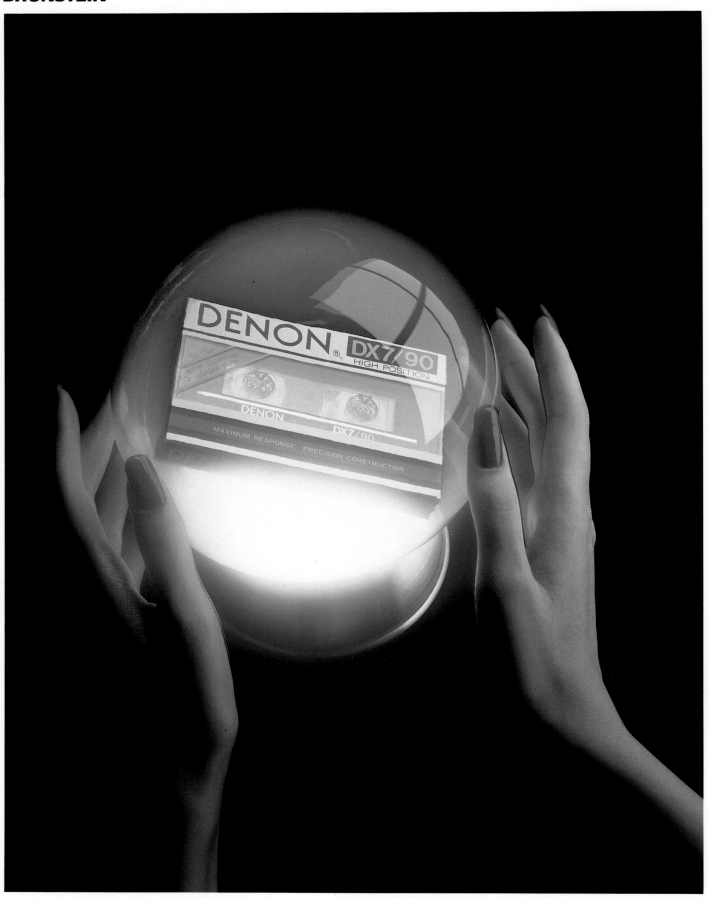

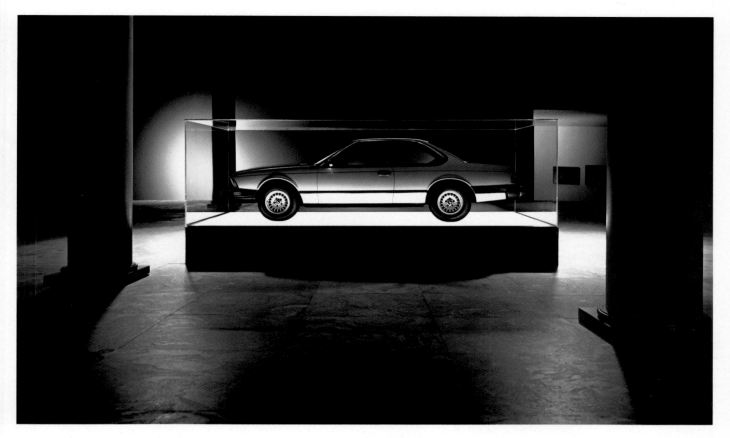

A CLASSIC CAR

When Bronstein was assigned to photograph a BMW 633 csi, the client originally wanted to shoot the car in a real museum showcase. But logistics and expenses created too many obstacles, so Bronstein decided to use a miniature set instead. The illusion of reality was achieved by underlighting the car with strobes to create a subtle but convincing contour of illumination. A foot-long C print of the results, also underlit, was then placed in a Plexiglas case positioned in a set— about 8 feet (2.43 m) wide in the rear and 18 inches (45.72 cm) at the front—constructed by a model maker. The image was shot with a 4 × 5 camera and 90mm lens. The delicate lighting and sparse museum setting created the impression that perhaps the Metropolitan Museum of Art had opened a strange new wing for "wheels."

TAPE ENCASED IN A CRYSTAL BALL

Bronstein's aim in this picture was to create a glowing crystal ball that nevertheless clearly displayed the product within it. He accomplished this objective with a double exposure and meticulous attention to lighting and detail. First, he wired the cassette from behind into the center of the ball. With a model's hands in place, Bronstein toplit and photographed the ball to create a clear image. Then, with the model's hands in the exact same position, he pumped dry ice fog into the ball to provide a haze effect. The ball was then lit from underneath to create a soft glow without obscuring the tape, and shot with a 4 × 5 camera and 150mm lens. The resulting image combined practical product identification with a bewitching suggestion of mystery and possibility.

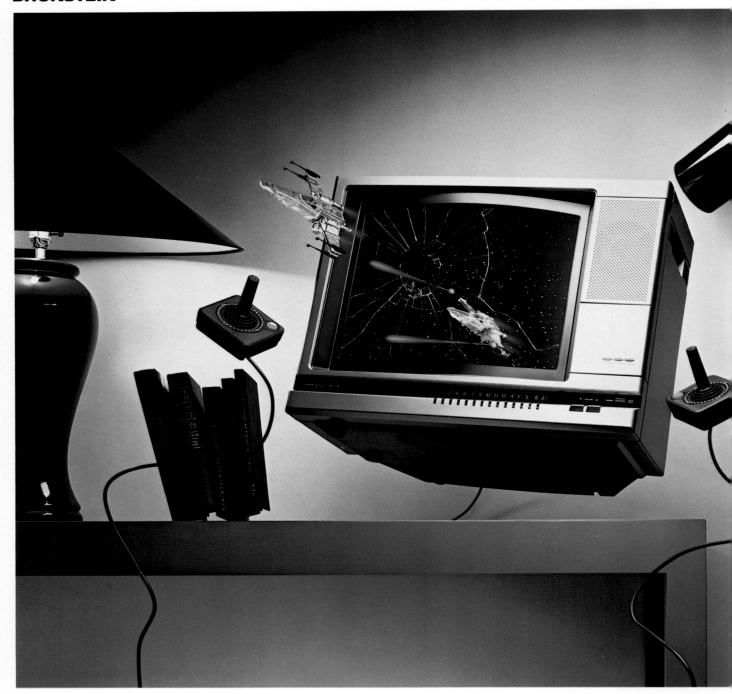

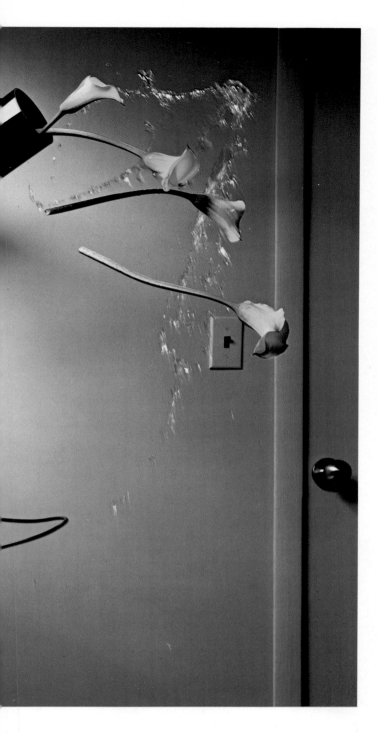

HOME VIDEO GAMES

When Mattel Electronics approached Bronstein with the concept that their home video games are just as exciting as arcade models, Bronstein opted for this modern-looking arrangement rather than the homey decor originally suggested by the company's advertising agency. The photograph shown here was created and used by Bronstein as a personal promotion piece, while Mattel chose a slightly different version (with a game board stripped into the television screen) for their advertising campaign.

Bronstein figured out the best way to make the objects soar. A gutted TV set was attached to the rear wall with a 1200-watt/second strobe placed inside it. A high tech vase was also attached to the wall and calla lilies were arranged with monofilament wire that was later retouched out of the image. Curved armature wire was clamped to two light stands at the front of the set and hooked up to the game's control cords.

To provide the burst of water, an assistant positioned himself behind the wall and regulated a homemade sponge-wringer mop rigged behind the vase. On signal, he pulled a string that closed the wringer, forcing water through a turkey baster placed between the wringer and sponge and onto the set. Bronstein shot the scene with an Arca Swiss 8 × 10 and 8-inch lens, using a three-foot-square (.27 sq m) bank light containing three 2400-watt/second bulbs above the set, and a 1200-watt/second light placed on the floor.

This background shot of the set shows the relative positions of the camera, lights, and props.

A side view shows the basic construction of the front and back of the set.

The gutted TV body and the bracing of the vase, flowers, and video control handles are all evident in this closeup view.

Here the books are shown as they were set up for the photograph. Note how the books are "glued" together.

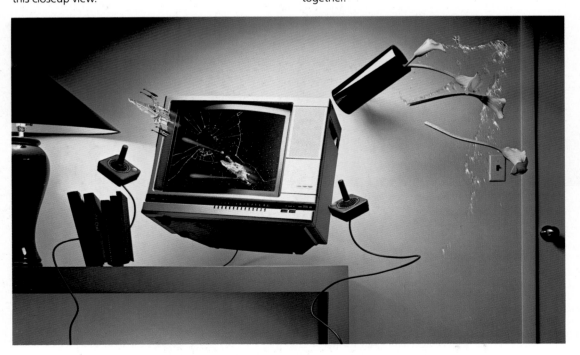

BRUNO

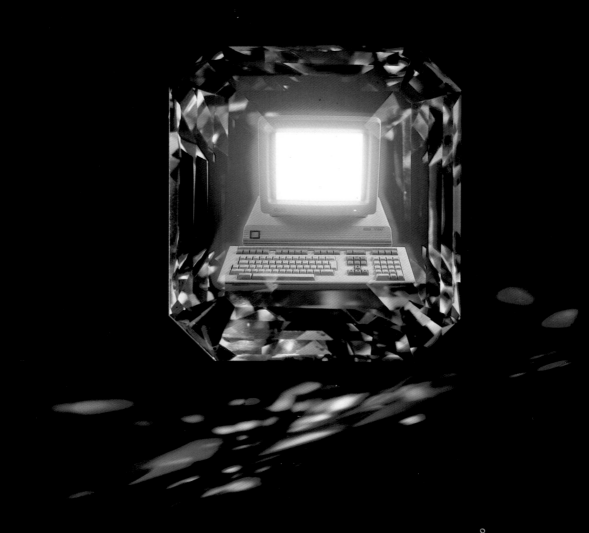

COMPUTER IN A CRYSTAL

When Bruno was commissioned to photograph this computer, he decided that the reflective qualities of real crystal, rather than a Plexiglas model, would make the image more lively. His first step was to rent a small, exquisite jewel which he photographed with an 8×10 camera and 53mm lens. Bruno backlit the crystal and angled a white card in front of it to capture the colored reflections. He then placed the computer on a 4 by 8-foot (1.22×2.43) sheet of

Plexiglas and made three distinct exposures with the 8×10 camera and 240mm lens. To register the luminescent screen, he overexposed the film; then, Bruno turned the screen light off, masked out the Plexiglas surface, and exposed the computer. Lastly, he masked the computer and with a blue gel on a backlight, created a vibrant glow. The final three-part computer shot was then photocomposed in the center of the crystal.

BRUNO

"I share all my secrets," Manhattan advertising and editorial photographer Bruno recently told an interviewer. "Knowing how to do it is one thing, but actually doing it is another." Born in Italy, Bruno, an associate of Cosimo's since 1980, has reason to be self-assured. Shooting for such agencies as Ogilvy & Mather, Doyle Dane Bernbach, and BBD&O as well as for such publishing clients as Dell, Omni magazine and Science Digest, Bruno has gained a reputation as a man who can make even the most unlikely dreams come true. His generous attitude about the kinds of information many photographers keep under lock and key is characteristic of Bruno's open-minded and confident approach to his work.

Bruno became interested in photography while he was in high school. Like many young photo enthusiasts, he worked on the yearbook and even headed the school's photography club. At Brooklyn College, however, he majored in liberal arts. But his love of the surrealistic work of René Magritte and the fantasy illustrations of Frank Frazetta led him to pursue a career in special effects, and after graduating from the Fashion Institute of Technology with photography as his major, he began freelancing in New York. "I had seen a lot of people who were working all day and hating their jobs. I wondered, what are we here for?" The answer, it seemed, was to devote himself to a profession with zest and enjoyment, so Bruno decided to put away his Shakespeare and take his chances in the competitive but

rewarding field of photography.

Although he began his career shooting still lifes, Bruno's work has always been a bit unusual. Instead of photographing vases and violets, Bruno found himself pairing fish with bananas; hardly formula fare for the traditional still life artist. An admirer of Cosimo's photographs, Bruno decided that special effects would allow him to express himself more fully, and he began to develop his technique along with a sensible attitude toward his own outlandish photographic schemes. "You have to know how far to go and just when to stop," Bruno explains. "The truth of the matter is that you'll never be 100 percent satisfied. If you keep changing every little detail, you'll begin to destroy aspects of the photo that you liked to begin with." Though trial and error is an integral part of Bruno's process, the photographer's philosophy is that "an idea may not come out exactly the way you envisioned it. But if it works, it works, and you'll know it."

Because he is often hired by advertising agencies that expect him to follow a layout, Bruno's foremost concern is to meet his client's expectations. "I always try to give the art director what he or she wants, but at the same time I always add my own personal touch," Bruno says. New ideas, he explains, evolve as a shooting takes place. The basic concept is provided by the art director; Bruno develops ways to improve or to enhance the image. By testing with Polaroids and by experimenting with slightly altered versions of a shot, he arrives at a final product that satisfies everyone involved.

Although Bruno uses such standard special effects techniques as fog filters and multiple exposures, he is also a master at conceiving realistic models. He often uses painted backdrops and miniature sets, lighting and propping his materials so that they appear to be life-sized. Experience has taught him that there's always a way—it's simply a matter of finding it, and of course, doing it. For a space shuttle junkyard shot, Bruno discovered that aluminum foil works better than plastic to convey the peculiar shapes of scrapped metal. Under his direction a model seated in the studio becomes an astronaut floating in space. Bruno's pictures, from a simple double exposure of a mannequin model to a complicated multi-exposure grid, reveal his capacity for transforming the ordinary to the amazing. "There is no standard in this business," Bruno maintains, "that says x must equal y. I use whatever I need to get the job done. If you get caught up in thinking that you must employ the same technique you used last time, you'll be knocking yourself out for no reason because each image is unique."

Being able to immediately recognize what works and what doesn't is a skill that Bruno has developed through experience, and like the maddest of mad scientists he is always ready to try another approach. The diversity of his images speaks for itself; Bruno has no pat answers, only a vat full of imaginative discoveries that lead to a fantastic special effects universe.

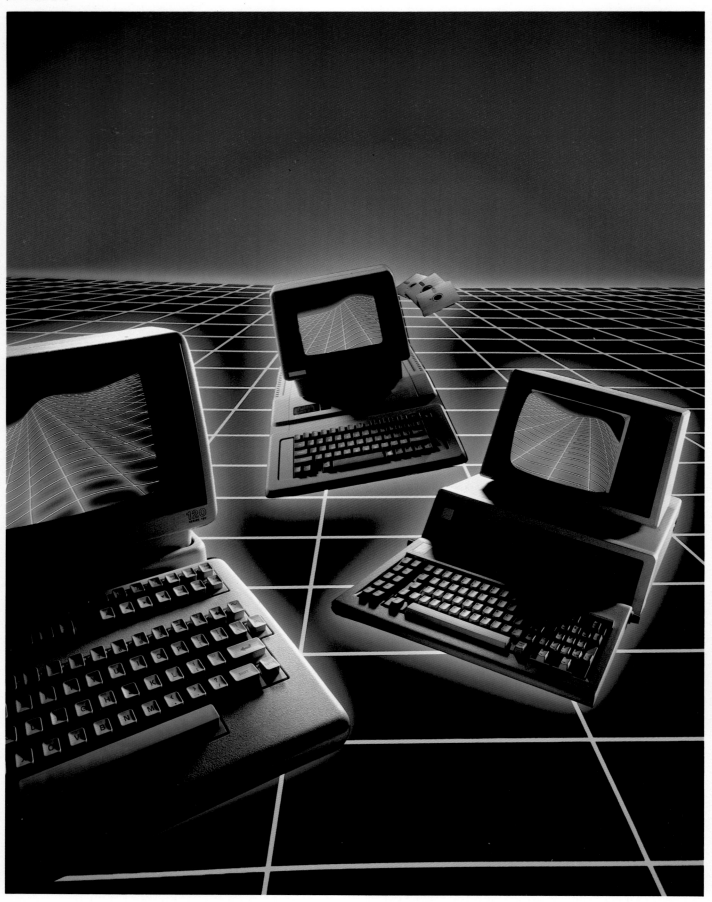

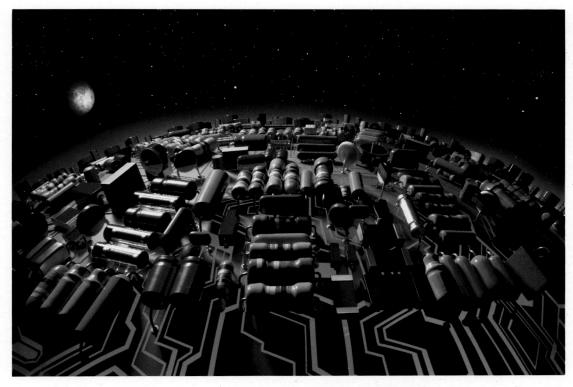

MINIATURE CIRCUIT CITY

Rather than use the original parts, which were only about one-sixteenth inch (0.16 cm) high, Bruno had a miniature city built with oversize chips. The set was built in perspective, with the foreground pieces as wide as four inches (10.16 cm), narrowing to one-half-inch (1.27 cm) pieces in the rear of the set. The pieces were placed in a five-foot (1.52 m) Plexiglas dome, which Bruno backlit and sidelit and shot with an 8 × 10 camera and 300mm lens. A glow, created by Plexiglas lit with gels, was double-exposed to accentuate the background.

Bruno then inserted the film in another camera and using a 165mm lens, exposed the starfield, provided by lights shining through pinholes in a black sheet of paper. Since the image still didn't seem quite complete, he decided to add another element. A trip to the Museum of Natural History in New York resulted in the final part of the image—a map of the moon which Bruno double-exposed in the corner. After painting over the names of the moon's craters on the map, the photographer transferred his film to a third camera and made an exposure with a 210mm lens. A piece of black paper was held in front of the lens to block off a portion of the moon and heighten its three-dimensional effect.

COMPUTERS ON GRID

To make this futuristic computer grid, Bruno began with a simple line drawing. The grid was made into a Kodalith and photographed with yellow gels and a 90mm lens to provide a dramatic perspective. In another 8 × 10 camera fitted with a 240mm lens, Bruno created a blue glow by photographing a backlit sheet of blue-gelled Plexiglas which had been masked to protect the bottom area of the image.

Next, to create the illusion that the computers were floating above the grid, he masked their shapes against another sheet of gelled Plexiglas and double-exposed the resulting glow. Each computer was photographed separately—as were the discs near the horizon line—and stripped into the image by a retoucher. The screen grids, created by green-gelled Kodaliths bent to proper perspective, were shot with a wide-angle lens and stripped into the final phenomenal photo.

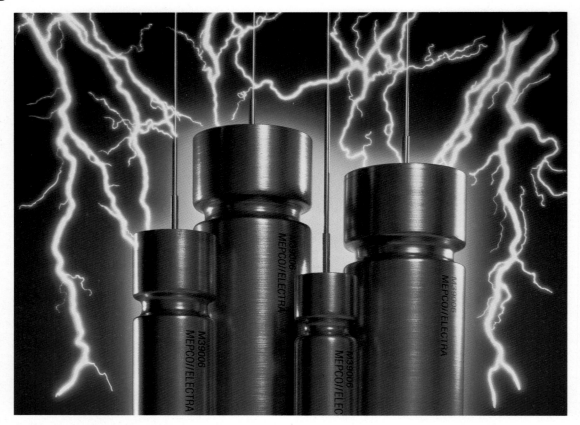

LIGHTNING ON COMPUTER CHIPS

Since his computer chip subjects were very minute, Bruno utilized a larger set made from brushed aluminum to obtain the proper perspective and maintain focus. The model chips were then placed in front of a sheet of Plexiglas and photographed with a 4 × 5 camera and 240mm lens. Sidelighting provided shadows and heightened the illusion of dimension. A second exposure recorded the blue glow, created by masking the computer chips and shining a blue-gelled light behind the Plexiglas. From stock lightning shots, Bruno then produced a Kodalith which was enhanced to ensure a dramatic effect. Using a second camera, Bruno exposed the lightning streaks and created this electrifying composition.

MOON IN ACRYLIC HEAD

Bruno photographed this portrait for the cover of an Isaac Asimov book called *Tragedy of the Moon*. The "moon" was actually a circular light fixture which was covered with clay, molding craters and a crack through which light could escape. Bruno placed red and yellow lights, hooked up to separate switches, inside the moon model and made two exposures with his 8 × 10 camera and 53mm lens.

Another exposure captured the sidelit craters, and a fourth, made while jostling the camera slightly, created a ripple effect on a piece of gelled Plexiglas placed behind the subject. Bruno then photographed a clear acrylic head with another 8 × 10 camera and 240mm lens using blue gels to provide the eerie outline. A starry sky shot with a 210mm lens was double-exposed in the background to make Bruno's "tragedy" a triumph.

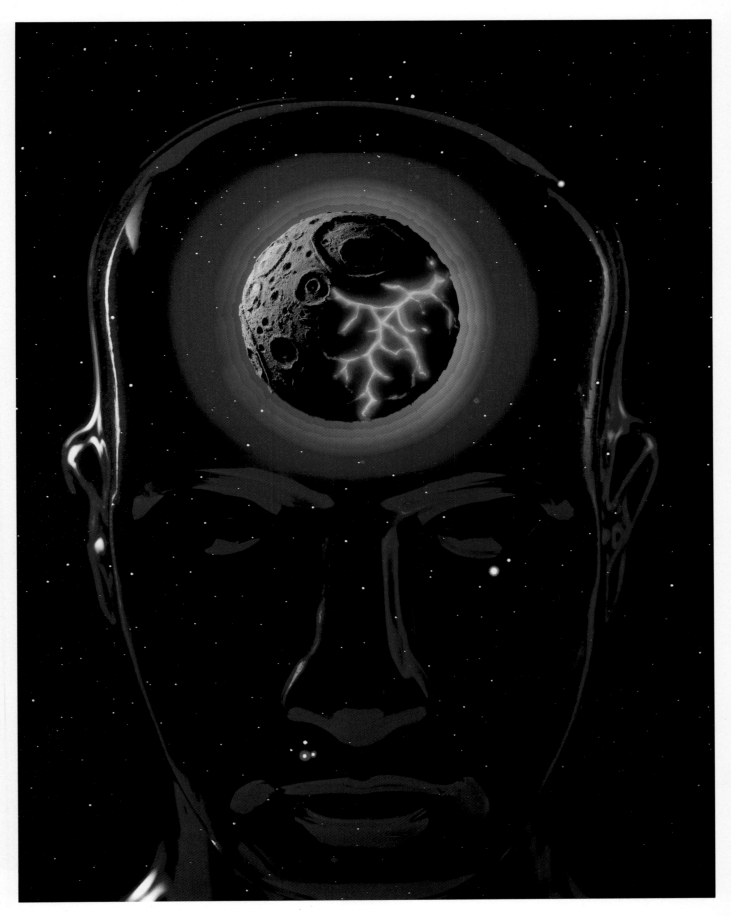

BRUNO

ASTRONAUT FLOATING IN SPACE

Bruno shot this space-age fantasy originally as an ad for Hershey's, later adding a planet to the image for his portfolio. His first step was to locate a proper spacesuit, so he called a movie prop shop in California. Since the suit was available for a rather steep price—$1,000 a day—he did the testing the night that it arrived, made the final photograph the next day, and shipped the suit back.

Bruno placed his "astronaut" in a chair surrounded by black material. As the model made gestures suggesting a floating movement, Bruno shot with strobe light and a 4 × 5 camera. The photographer then duped the image onto a starry-sky background that he had created by backlighting a piece of black paper. Because twenty to thirty lights had been placed behind the tiny holes in the paper, a fire extinguisher was always at hand during the shooting.

After submitting this image to his client, Bruno decided to add a third element, and commissioned a model maker to paint a small sphere. The acrylic clouds and blue swirls of the planet were shot in soft focus with a 90mm lens on the 8 × 10 camera and double-exposed into the original image.

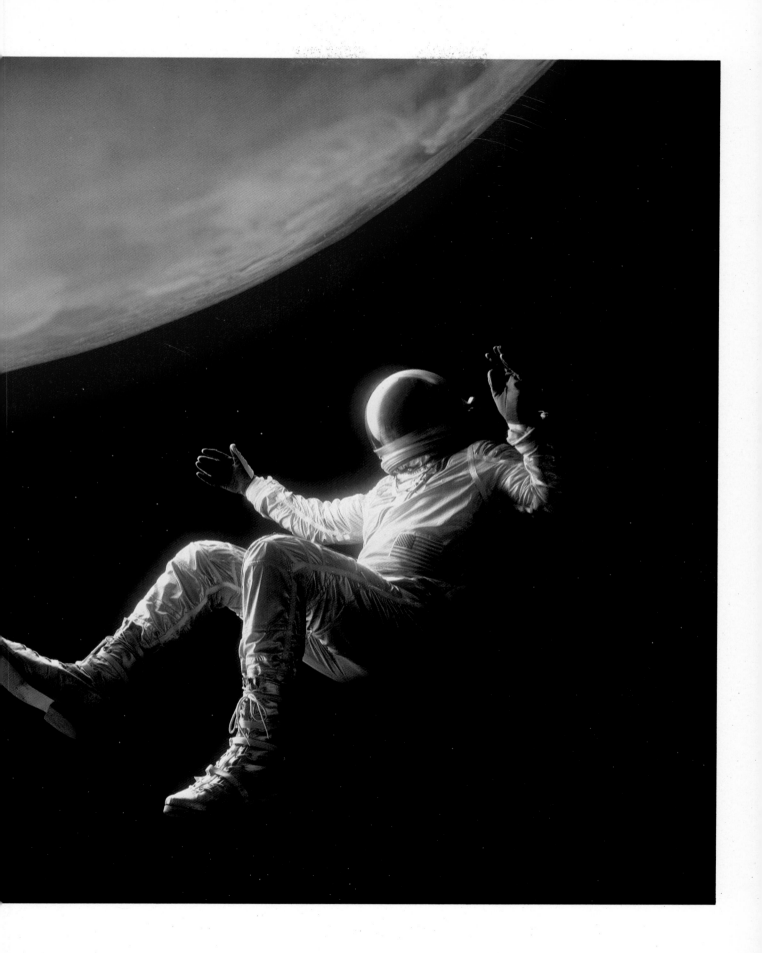

SPACE SHUTTLE JUNKYARD

This space shuttle junkyard, photographed for a *Science Digest* article on the cost-effectiveness of space equipment, was the result of careful planning and construction to create a believable setting. Because the art director was concerned that plastic pieces might look fake, Bruno decided to try a combination of plastic and aluminum foil. The foil could be easily shaped and molded into sharp edges to maintain a realistic effect. The 18-inch-square (45.72 cm) set was placed on a tabletop and shot with a 35mm camera and 20mm lens. He chose the small format camera because the sharp grain provided by a larger format would be more likely to register telling details that would reveal that the scene was a model. Bruno rented a stock painted sky for the background and blasted 250-watt bulbs and a variety of reflectors into the clouds to offset his imaginative junk wonderland.

CHIVAS REGAL IN THE SAND

For this Chivas Regal ad, Bruno managed to create the mood of a relaxing day at the beach—in the studio. Using a combination of sand, plaster, and binder, a bottle was constructed. A metal plate of the Chivas label was made and attached to the bottle. The entire prop was then sandblasted. Bruno found that raised letters "read" better than embossed, though he experimented with both types of lettering. The bottle was sidelit, as was the painted backdrop, to simulate the impression of afternoon sun. To maintain the proper hues on the serenely clouded sky, Bruno used pale blue gels. The initial shot of the bottle was made with a 300mm lens on the 8 × 10 camera. The background was a separate exposure. The image is reminiscent of the wonderful juxtapositions created by Magritte, an artist Bruno has always admired.

KEY AND PYRAMID

For a key company's poster, Bruno used an elegant, high tech Plexiglas pyramid. He suspended a bulb in the center of the pyramid to accentuate its levels of color, and with armature wire attached the construction along with a key to a painted backdrop. To create the rainbow-like luminosity, Bruno placed a light off to the side and positioned cutouts in front of it to simulate sunlight streaming through the clouds. The key and pyramid were backlit, and additional highlights were provided by reflector cards placed at the front of the set. Bruno shot the image with a 165mm Super Angulon lens on the 8 × 10 camera, creating a highly dimensional photograph in a single exposure.

MODEL WITH CAP

To warm up this mannequin model for Weller, Bruno placed his client's product—a heating cap—on her head and positioned her silhouette against a large sheet of Plexiglas, gelled with blue. In the center of the blue gel, he cut a perfect circle and inserted a yellow gel. He made an exposure with his 8 × 10 camera using a 240mm lens, backlighting the Plexiglas and adding a soft spotlight on the mannequin's profile. He then transferred the film to another 8 × 10 camera and double-exposed the neon outline, created by masking the cap and shooting with a blue gel and 300mm lens.

BRUNO

SPHERES ON A SCALE

For a pharmaceutical company, Bruno was asked to place two spheres on a scale to illustrate the advantages of two types of medication. To create the proper illusion, Bruno had a scene painted on a backdrop and placed behind the clear Plexiglas sphere. The mountains were created by cardboard cutouts and added to the scene. The sphere slightly magnified the scene and added the proper perspective. The spheres were placed on a sheet of underlit Plexiglas and photographed with a 4 × 5 camera and 500mm lens.

Bruno then shot the scale which was placed on the miniature set. The scale was constructed in perspective and masked with black tape to attain sharper edges. To add to the sense of perspective he used a 165mm Super Angulon lens. Painted cracks on a sheet of cardboard provided the subtly textured surface beneath the scale. With another camera, Bruno then recorded the glow of the scale, created by a gelled Kodalith, and the three shots (set, scale, and glow) were then combined on 8 × 10 film which was then photocomposed in position with the shot of the spheres on 11 × 14 film to create the final image.

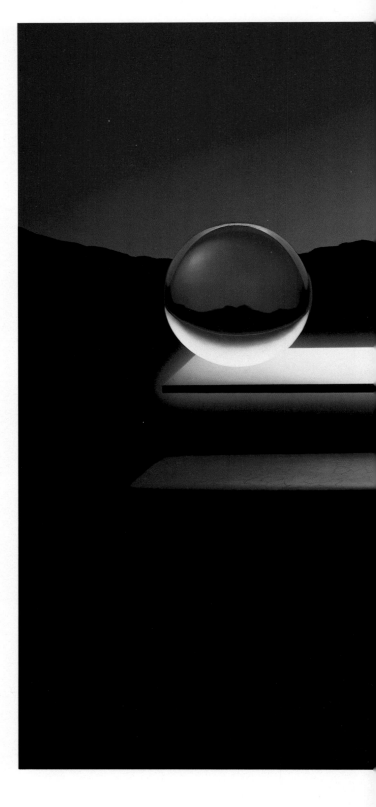

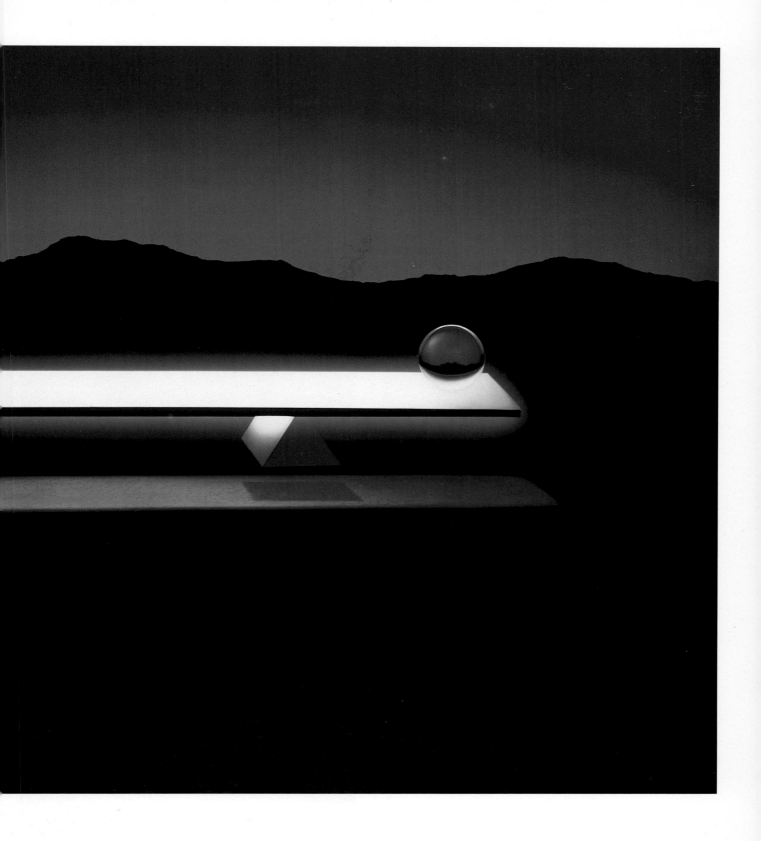

TECHNIQUE
SPHERES ON A SCALE

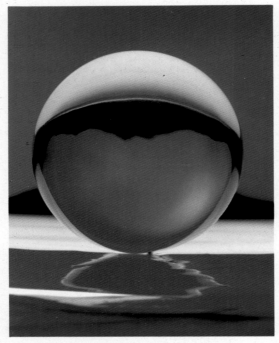

A mountain scene was painted in perspective on canvas and then placed behind the sphere. The sphere magnified the scene.

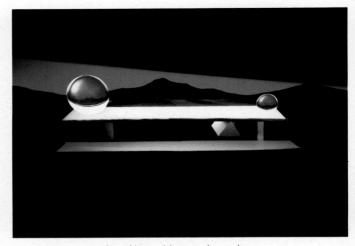

The spheres were placed in position on the scale, which is actually a sheet of Plexiglas lit from below.

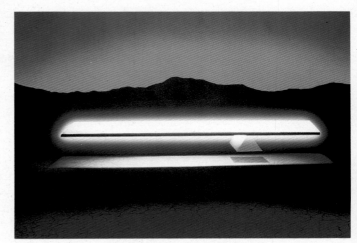

A second exposure of the scale was made to provide the glow. The image was combined with Kodalith film and a colored gel to create the halo around the scale. Black tape was used to mask the edges for sharpness.

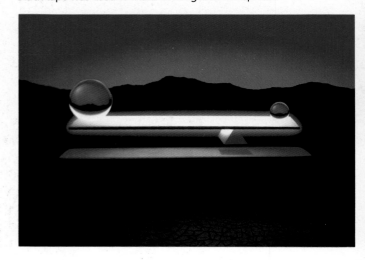

COSIMO

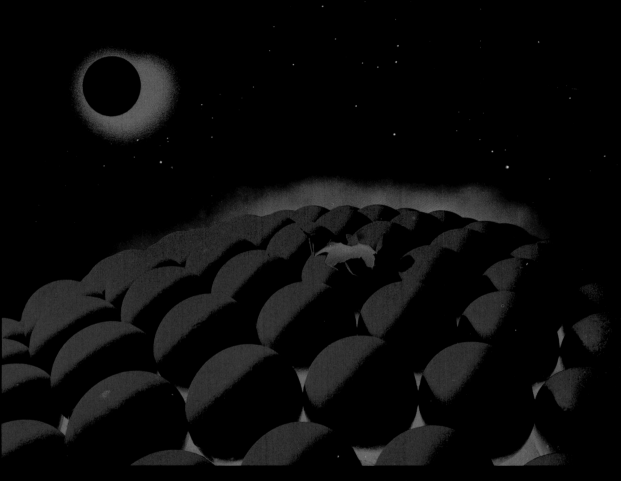

PING-PONG BALL PANORAMA

To create this Ping-Pong ball panorama, Cosimo placed painted balls in a four-foot-wide (1.22 m) clear Plexiglas dome. Lights were covered with red and purple gels and positioned beneath the dome and on the sides of the set. Cosimo tore the center ball into an interesting shape and pointed a red gelled light up through its center. He shot the set with a 8 × 10 Deardorff camera and a 90mm super angulon lens.

A second exposure recorded the impression of an eclipse in the background, created by a black spherical card lit from behind. Lastly, he exposed the sky, which was provided by pinholes in black paper lit from the rear. The result was an enigmatic and alluring spherical vision.

COSIMO

One might quite reasonably expect a man who calls himself Cosimo and makes pictures that are out of this world to be a cosmic wizard zapped to earth from the Milky Way. But instead Cosimo is a Brooklyn-born New Yorker who studied design and advertising illustration at the Pratt Institute and the School of Art and Design in New York. About seventeen years ago he gave up his career as an art director/illustrator, left his publishing company job as a designer of book jackets, and took up photography. "The basic transition took me a couple of years," Cosimo recalls, "but my sense of design was very helpful in making the switch from paint to film." Although photography began as a hobby, Cosimo explains, he soon found he was enjoying making pictures more than he planned, and it seemed only sensible to devote himself full time to his new and unexpected vocation.

Even when he first began making pictures, Cosimo's work was always just a little bit out of the ordinary. "My photos weren't called special effects back then," he remembers, "though they're labeled that now. I always wanted to make pictures rather than take them, and it just so happens that to accomplish what I envision requires a certain amount of unusual props and methods." Because of his design background, Cosimo most always finds it helpful to sketch his ideas before he makes a photograph. Once the sketches are complete, Cosimo begins to construct or search for his imaginative ingredients. Before actually shooting, he often meets with model makers, background painters, and stylists. Many of his "miniature" sets are actually quite

large, filling up an area as large as 10 by 12 feet (3.04 × 3.65 m). "I like to keep my sets as large as possible," Cosimo explains, "so that I can get a lot of detail into the final photograph."

To Cosimo the use of light is the most important aspect of photography. "There's no magic formula—you just have to be observant and intuitive. You must keep your eyes open, watch what light does, and simulate it." Although his pictures have an "out of this world" glow, it is immediately apparent that the basic logic behind Cosimo's lighting techniques is consistent with reality. Perhaps that is why everything Cosimo photographs—from a horse with wings to a pink cherub floating in space— seems so undeniably real.

Although formal art training has had a strong influence on his sense of design, Cosimo claims that he doesn't really know where his ideas come from. But from his most complicated to his simplest shot, Cosimo's work is a sublime balance of visual and conceptual elements. "I don't like to analyze things," Cosimo says; "I just go with my gut feelings." Yet he contemplatively admits, "Everyone has a different blend or mixture of things they learn and perceive. And everything one creates is a result of personal experience and learning."

Cosimo uses a variety of special effects methods, but it's the idea rather than the technique that determines the success of his work. To Cosimo special effects photography is much like an odd kind of detective work; he conjures up his own mysteries and then unravels them clue by clue. "Solving problems is the fun part," Cosimo feels; "I love figuring out how to create an image." Sometimes his solutions may seem more like problems in themselves: finding a white horse that will rear up on cue and a model who knows how to ride bareback and doesn't mind posing nude; or deciding that the two tons of sand he's just lugged into his studio isn't just the right color and must be dyed a more vibrant hue.

When he started in this field, Cosimo reflects, there were fewer special effects photographers. Today the field has become much more sophisticated, and because there are so many pictures available, a photographer must create images that are arresting enough to capture both client and viewer. The successful special effects artist must be more than unique—he must be phenomenal, which is indeed just what Cosimo is. "It's not just a matter of making unusual pictures," he says. "You must begin with great thoughts."

Apparently clients, including such prestigious advertising agencies as Grey, N. W. Ayer, and Doyle Dane Bernbach, believe in Cosimo's ability to communicate their ideas. Whether for a poster, an advertisement, or the television commercials which Cosimo has lately been directing for such accounts as Scotch video tapes, Lipton herbal tea, and Canon, Cosimo always has a plan like no one else's. Though he's just a regular guy from Brooklyn, there's more than just a little magic in the way he sees the world. With wit, style, and a remarkable sense of what should go where, Cosimo turns his cosmic fantasies into masterful visual realities.

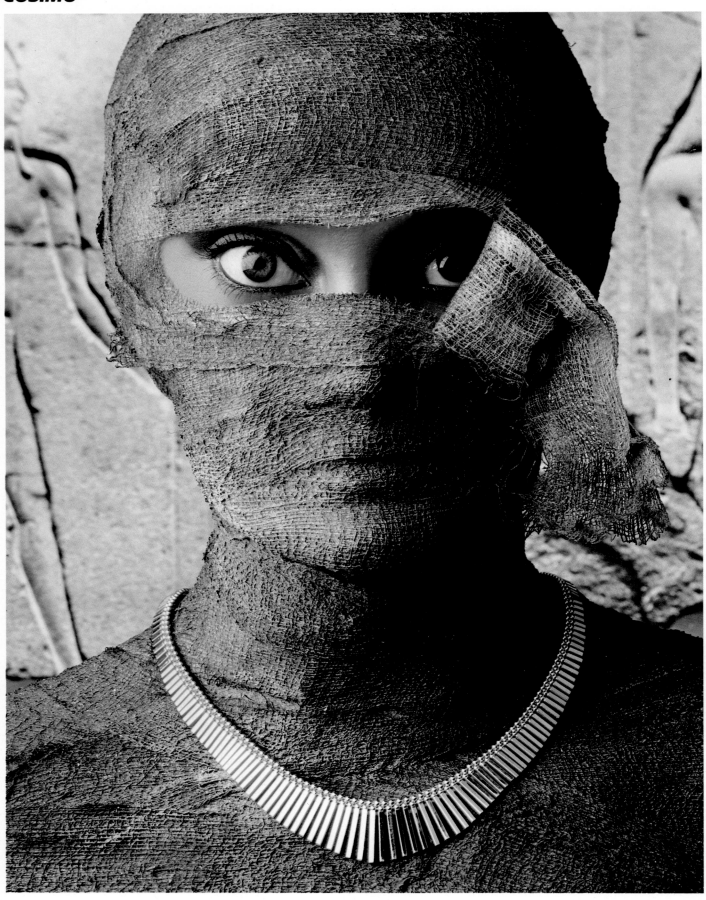

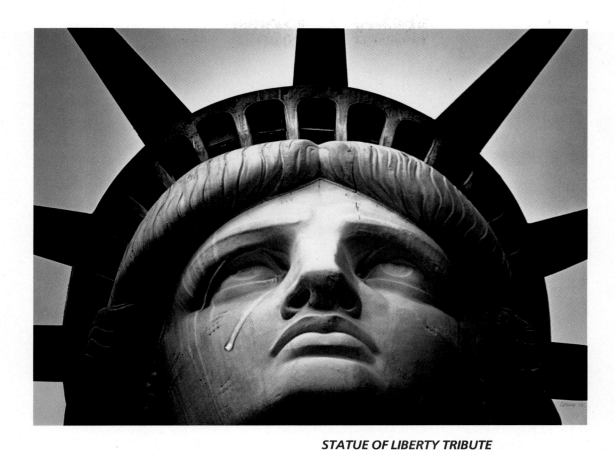

STATUE OF LIBERTY TRIBUTE

For this poignant shot of the Statue of Liberty, Cosimo—a born-and-raised New Yorker who had never before visited the city's leading lady—made a day-long pilgrimage with a variety of lenses and equipment. Using a 500mm mirror lens on his 35mm Nikon, Cosimo found a unique angle from the very edge of the island. The natural lighting created a romantic haze in the background. Cosimo returned to his studio and discovered that from the day's shoot this image most intrigued him, but something wasn't quite right. With a grease pencil he whimsically drew a tear on the image and liked the impression it created. Cosimo then went home and placed a drop of glycerine on his wife's eye. He took the photograph of his wife along with an 8 × 10 dupe of the 35mm Kodachrome of Lady Liberty to a photo-retoucher, who painted an identical tear on her face. Cosimo later made a poster of the photo which he used for a successful self-promotion piece.

MUMMY AND MODEL

Originally an ad for an Aurea necklace, Cosimo shot this photo around the time of the King Tut exhibition at the Metropolitan Museum of Art in New York. The art director had suggested using a mummy as the model; Cosimo decided a pair of beautiful eyes would liven up the image, so he hired a Zoli model who fit the bill. An assistant was sent to the museum to photograph the various Egyptian hieroglyphic patterns on the walls, and one of the pictures was made into a 20 by 24-inch black-and-white print which Cosimo used for the backdrop. A model maker stained and powdered some gauze to age it properly and covered a mannequin's head. Cosimo lit the mummy model with a bank light bounced off small white reflectors that were placed above and aimed at the necklace. Again he used an 8 × 10 Deardorff view camera. With grease pencil he marked off the mannequin's silhouette on the ground glass and then made an exposure of the real model using the same lighting techniques. The eyes, enlarged a bit for an even more startling effect, were then stripped into the dye transfer print.

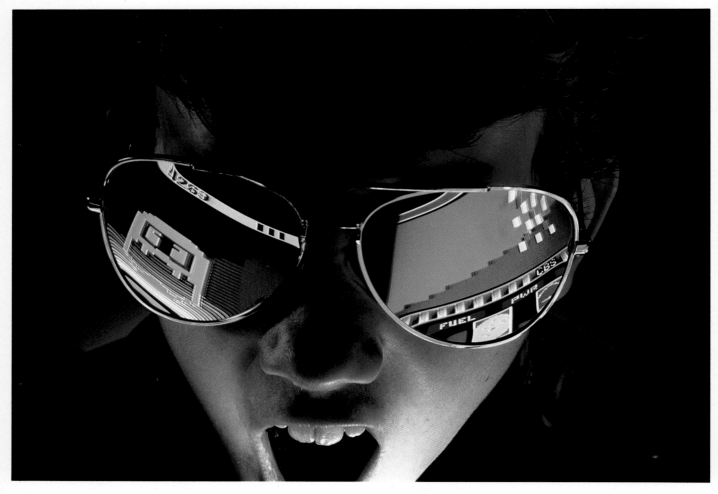

MIRRORED GLASSES

In this ad for Atari children's video games, Cosimo wanted to generate the enthusiasm that kids feel for computers. His first step was to make a visit to the product's manufacturer where he photographed the video game images off high-quality monitors using his 8 × 10 camera. Then he made enlarged transparencies of two of the resulting images. He placed the transparencies over two light boxes which were carefully positioned so that the images would reflect into the boy's mirrored glasses. He photographed this eerie effect with a 35mm wide-angle lens, using backlighting and colored gels to enhance its futuristic feeling.

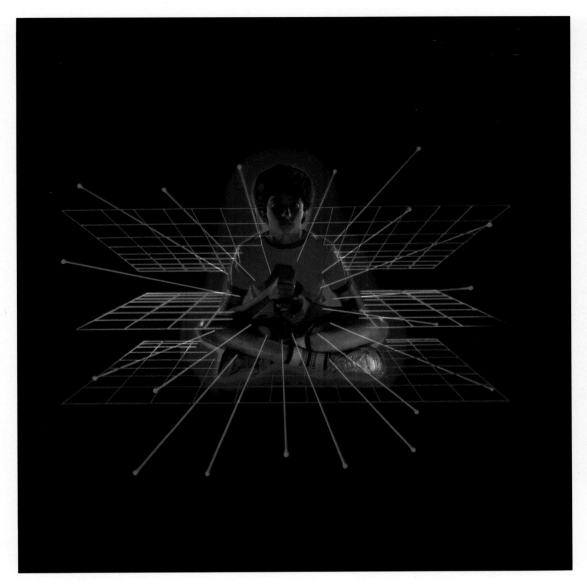

BOY AND GRID

Cosimo created this image on one piece of film for the cover of a book about children and video games. Using four different Deardorff 4 × 5 view cameras, he double-exposed the film from one camera to the next until all the ingredients were registered on a single transparency. Separate templates were drawn and placed on each camera to ensure precise registration.

In addition to a straightforward shot of the boy photographed against a black background, Cosimo made three other exposures. The green lines were created by a black-and-white ink drawing from which he made a Kodalith negative that was placed on a sheet of milky Plexiglas and photographed with gelled light. Another exposure recorded the magenta lines, also created by a Kodalith with colored gels. Finally Cosimo masked the shape of the boy, which he cut out and placed on a black card behind the milky Plexiglas. He then made an exposure with blue gel to produce the glow. The final photograph became a fantastical visual jungle-gym of color and dimension.

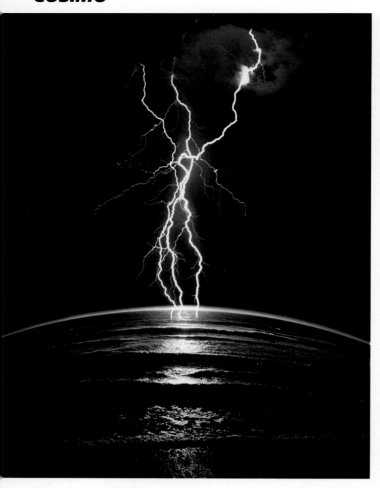

LIGHTNING AT BEACH

For this photograph used as a bank advertisement, Cosimo was asked to produce an unusual-looking horizon. He went to the Jersey shore where, with a fisheye lens on his 35mm camera and various filters, he shot a glistening sunrise. The ghostly glow along the horizon line was created in-camera, by masking a sheet of Plexiglas. Back in Manhattan, Cosimo scoured a stock photo agency for a standard lightning shot and combined the two images on one piece of film. A calm morning at the beach was magically converted into an electrifying moment.

MOON AND EARTH

When asked to provide a cover for a science fiction anthology, Cosimo decided a setting reminiscent of the surface of the moon would be appropriate. With a model maker, he constructed an 8 by 6-foot (2.43 × 1.82 m) set from clay and dust that would make even a seasoned astronaut look twice. Then he called NASA and asked for some pictures of the earth that were shot from outer space. When the photos arrived, he blew up the best image and pasted it on a round piece of milky Plexiglas which he lit from behind. He shot the set against black velvet with a 4 × 5 camera and 90mm lens.

To create the background of stars, he double-exposed pinholes in a black sheet of paper. The double exposure ensured that the stars would appear sharp and clean rather than blurred as they would have if photographed with the set. One unsoftened, simple floodlight on the left provided the illumination.

THE ENTERPRISE

Cosimo was asked to dramatically illustrate this AMT model of the spacecraft *Enterprise*. The model was supplied by the toy company but an unusual background was needed. First Cosimo went to a planetarium and bought a slide kit of various constellations. By using pinholes in black paper, gelled lights, and projecting the slides on the background, Cosimo was able to produce a startling view of outer space.

A Styrofoam ball was handpainted with Krylon paint and then twirled on the tip of a pencil (held off frame) during the exposure to create the blurring motion. The miniature spacecraft, suspended from a rod leading straight back into the background, was toplit with magenta gels while blue gels enhanced the illumination on the left-hand side. Because bright lights would have melted the plastic toy, tiny bulbs attached to a battery were placed inside the ship, and to compensate for the low-powered lights, Cosimo made a two-minute exposure. Large sheets of acetate sprayed with white paint provided the clouds.

Cosimo shot the image with a wide-angle lens on his 8 × 10 view camera to create a distorted sense of scale and the impression that an authentic spaceship was on its way to, well, who knows where?

VIVITAR FLASH EXPOSURE

For this Vivitar ad, Cosimo made a large transparency of a NASA Earth photo which he enhanced with filters and gels after suspending the image from a rod. The smoky-star effect was created by projecting slides onto a black background and covering the projectors with various gels to provide a modulation of color intensity. The Vivitar flash was fired into the lens to provide the vibrant burst of light. Cosimo used four exposures to reach the final image. In addition to the NASA Earth, the star field, and the flash, the photographer created an eerie blue glow by masking a sheet of Plexiglas.

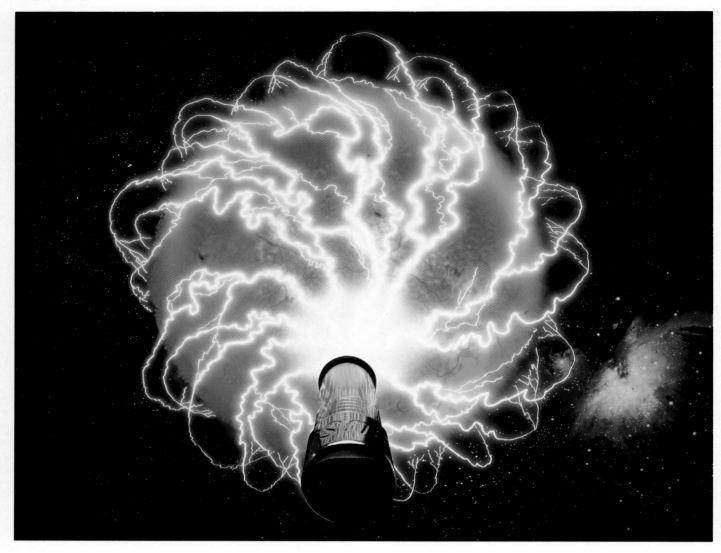

BALL OF ENERGY

For Amerford Fuse Company, Cosimo wanted to demonstrate the incredible energy of a fuse, so he created this vibrant energy ball. First he shot the fuse separately using an 8 × 10 camera and 90mm lens. Then he created a series of overlays and exposed each piece of art work separately on one piece of film. A Kodalith rendering of electricity lines was thrown slightly out of focus during one exposure to create the blurring impression of movement. With the help of gels, diffusion materials, and a milky Plexiglas background, each overlay registered as a dynamic color or texture. The final exposure recorded the stars, again provided by pinholes in black paper and projected slides of the Milky Way.

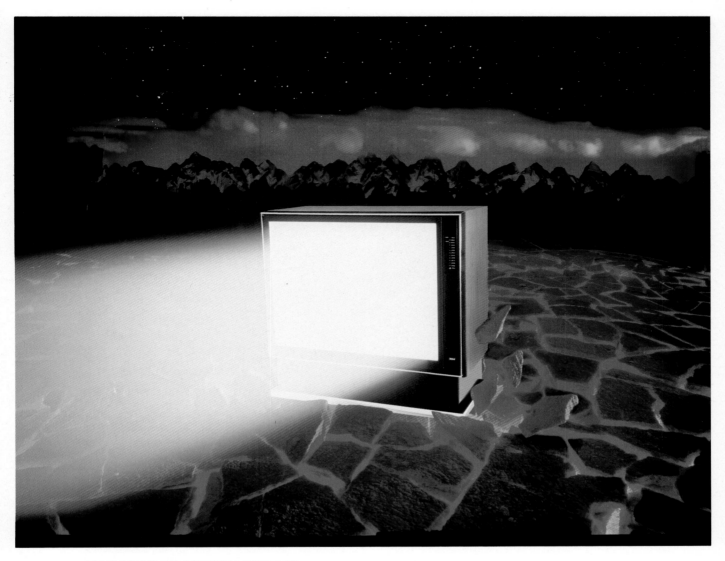

TELEVISION ON CRACKED SURFACE

Cosimo created an 8-foot-deep by 10-foot-wide (2.43 × 3.04 m) set of Plexiglas and broken plaster. The cracked surface, lit from beneath with colored gels, was shot with a 90mm lens on an 8 × 10 view camera. In addition to the exposure of the set, and one of the TV, Cosimo made three other exposures to create the final image. A mountain range constructed of Styrofoam and plastic was double-exposed in the background, and a glowing shaft of illumination was created during another exposure by placing a light behind a strip of Plexiglas. Lastly, Cosimo exposed the pinhole stars. This five-exposure image presents an ordinary rectangular shape in a characteristically cosmic Cosimo showcase.

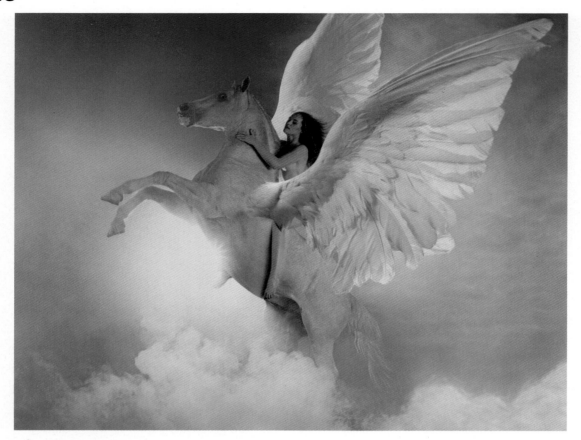

WINGED HORSE

Originally shot for Pegasus jeans, making this photograph presented a host of unusual problems. The first difficulty was finding a horse that would rear up on cue without the help of reins. After a good deal of research, a golden horse and his trainer were brought to the studio. Cosimo sprayed the horse with nontoxic white paint and positioned the trainer out of camera range. Finding a model was another obstacle. After weeks of casting, Cosimo came up with a model who would ride bareback—and pose bare.

Cosimo placed dry ice smoke machines in various locations in the studio and used troughs of dry ice across the front of the set. Water was poured onto the ice to produce additional clouds and enhance the dreamlike aura. He shot the image with a 2¼"-square camera using blue seamless as the backdrop. A light placed behind the horse, facing the camera, created a dramatic burst of illumination. A dove was photographed separately with the 2¼"-square camera, and the wings were later stripped into the dye transfer.

FLOATING CHERUB

Cosimo's first step in creating this poster for Cherbutti Films was to locate the perfect cherub, and after extensive casting, he finally found the quintessential cupie. But what twelve-month-old baby would do anything other than just what she wanted, just when she wanted? To solve his unique modeling problem, Cosimo photographed the baby in a number of different poses of her choice with a 2¼"-square camera and then stripped together seven various pieces to form the final image of torso, head, legs, and arms. The dove wings were photographed separately in the studio with a Hasselblad and 120mm lens and then photo-composited with the baby and the cloth.

A 16-foot-wide by 20-foot-long (4.86 × 6.09 m) crater base, constructed of Styrofoam, plaster, and clay by a model maker, was shot with a 35mm camera and 20mm lens. This large set, with a planet suspended in the center, was placed before a 26-foot (7.91 m) painted backdrop, lit with gels to intensify the colors. The stars (pinholes in black paper) were made by a double exposure. The various images were combined to produce this high tech vision of an extraterrestrial tot.

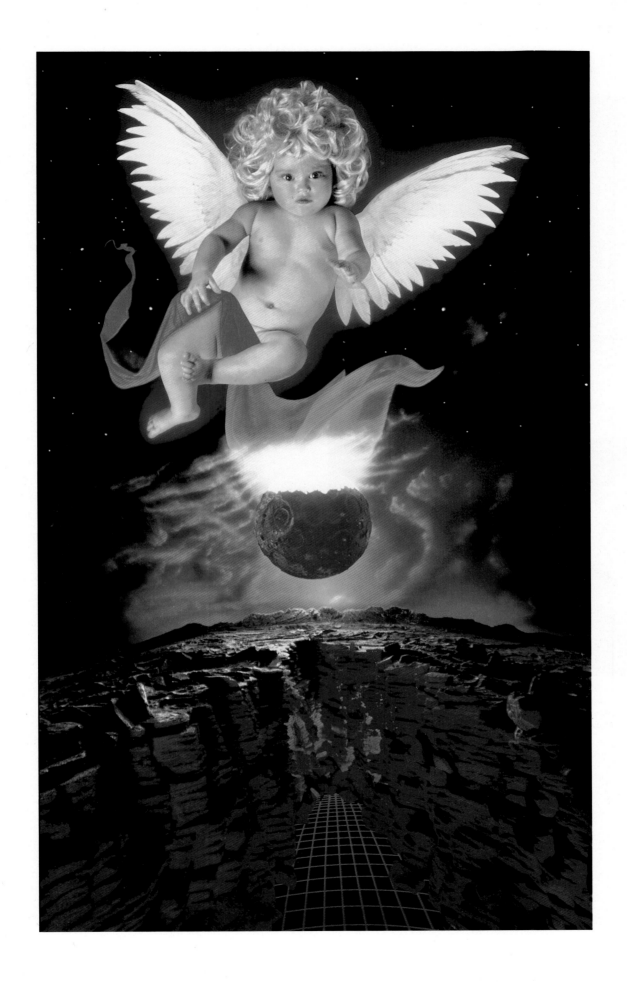

TECHNIQUE
FLOATING CHERUB

This final photograph of the cherub is actually a composite image created from seven different transparencies.

The floating cloth and the wings are also shot separately, but carefully positioned within the frame for alignment in the final image.

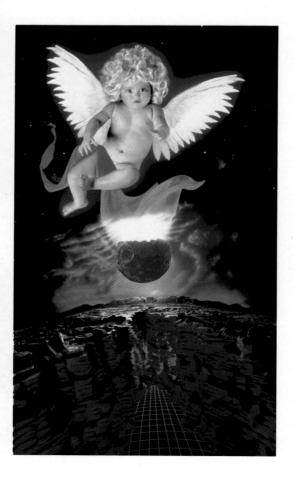

This composite shows the cherub, cloth, and wings as combined for use in the final transparency.

The set is then photographed against a painted background.

The grid is also photographed separately and then combined with the other transparencies for the final photograph.

GROHE

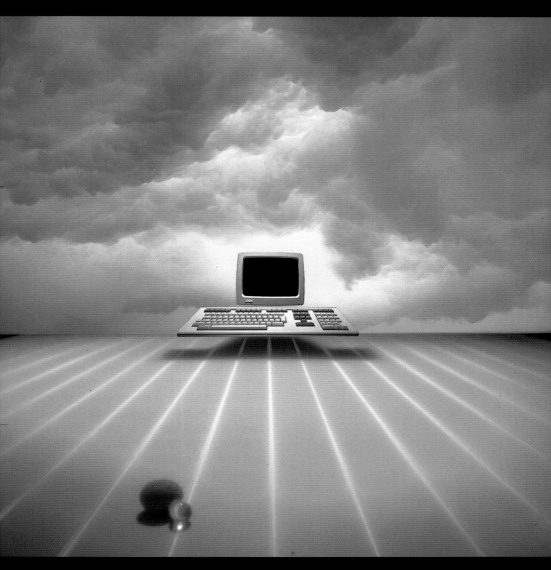

A FLOATING COMPUTER

Although the client had originally asked for a painted backdrop of clouds, Grohe preferred to manufacture his own to provide a greater sense of surrealism. The clouds were created by filling a giant tray of polyethylene with dry ice. He aimed fire extinguishers into the tray, which resulted in approximately 144 square feet (13.37 sq m) of billowing clouds. A strobe light placed behind the clouds provided the strange luminosity. The image of the computer was generated separately. Grohe balanced the CRT portion on a steel beam and placed the keyboard on a large, cylindrical

sheet of Plexiglas and made an exposure. A third sheet of film was exposed for the foreground, which was actually strips of white Formica arranged on an 8 by 16-foot (2.43 × 4.86 m) Plexiglas table. The gaps between the strips were diffused by a fuzz filter. To provide the computer's "shadow," Grohe suspended a cardboard cutout above the base surface of the set, and the third exposure—with a rock and marble added for fun and visual appeal—was shot using a brown-orange gel on a soft spotlight. Grohe stripped the three exposures together to make the final image.

Steve
GROHE

Steve Grohe, a Boston-based photographer, has a rare talent and affinity for visually translating technology. With such clients as Unitrode Corporation, Apollo Computer, and Digital Equipment Corporation, it's understandable that like his sophisticated subjects, Grohe's work must remain on the leading edge. To depict the characteristics of computer hardware and software, Grohe has developed an intricate understanding of how and why things work. Though he majored in management in college, he spent his summers in a variety of photography-related jobs—he apprenticed in a motion picture studio, assisted in a small portrait studio, and worked in a dye transfer lab. In addition, ever since he was a child fascinated by model airplanes, Grohe has enjoyed making things. His studio, which Grohe jokingly calls a "body shop," is equipped for soldering, welding, painting, and just about anything else that needs to be done. Grohe constructs many of his props himself, using fiberglass, castings, as well as working under low-power microscopes to build scale models that are precise replicas of the originals. "I've always been intrigued by technology, machinery, and art," says Grohe, "so I decided to combine my interests in my photography."

What is the key to the deceptive simplicity of a not-so-easy-to-make Grohe photograph? Perhaps it's his insistence that "there are no rules. People are used to thinking of traditional solutions to photographic problems, but we do whatever we must to get the shot." His job is making the intangible, tangible. For Grohe, that often means "thinking backwards." First, says Grohe, he designs the photograph in his head. "Then, I figure out how I will do it. Even the most

complex project can be broken down into tiny increments."

Grohe explains his photographs in terms of two essential functions—to impress and to inform. "I always ask my clients which they want to take precedent," he says. To inform or to tell a story may call for simple, straight documentation, but to impress requires a theatrical special effect that will turn keyboards, display screens, and terminals into exciting visual kaleidoscopes. Usually Grohe's clients have a specific marketing objective in mind and want to communicate a distinct idea. It's the photographer's job to "take these hard-boiled, concrete requirements and mold them into something that is beautiful as well as informative," says Grohe. The mystery, he maintains, is not figuring out how to create a special effect, but determining the right effect to most accurately and dynamically express a particular concept.

Grohe makes all of his photographs on an 8 × 10 camera. Because many of his pictures appear in trade publications, brochures, or annual reports as full pages or spreads, to ensure accuracy he provides his clients with film that is very close to final reproduction size. Although he occasionally goes out on location, most of Grohe's work is done in his studio, which is stocked with such equipment as fisheye lenses for his view camera, peculiar diffraction grids, and unique machinery used for moving either his subject matter or the 8 × 10 camera. Grohe exclusively uses electronic strobes to light his pictures and has even designed micro strobes that can be inserted in his miniature constructions. He never retouches his photographs, and often he does his own stripping.

Though most of Grohe's subjects are in themselves rather monochromatic, his images provide a strong interplay of color. Because he often shoots for trade publications which may not possess the most sophisticated color separations, Grohe reveals, he began overemphasizing color by using theatrical gels to dramatize reds or brighten blues. In this way, he could be sure the colors would be outstanding, regardless of the separation or reproduction quality. "This kind of color saturation eventually developed into a personal style," Grohe says, "but it came as a natural evolution as I reacted to a recurring problem." Frequently Grohe experiments with unusual color combinations, thus exploring the effect of advancing and receding hues on perspective, dimension, and mood. But even though there are certain recognizable aspects of his style—"a sort of continuity that is inherent in the work of any individual who is exerting a lot of control"—each Grohe photograph is unique, solving a specific problem in a singular way. "No two clients come to me with the same visual problem," Grohe explains. "I may have a definable style, but I don't ever use the same gag twice."

"My trick is to depict technology in a palatable fashion," says Grohe. Rather than conjuring up the most complicated photograph he can imagine, Grohe seeks simple and direct solutions. "Using this process of distillation to reduce a photograph to its basic components is actually much more difficult than making a complex image," he explains. Adds his studio manager, Rick Metzger, "We're not after gratuitous special effects, and we never use special effects just for the sake of using them." Instead, Grohe employs special effects as the natural language of a high-tech world, and his photographic vocabulary is both lyrical and "easy-to-read."

DISKS ON GRID

This "simple" double exposure was made with the help of a giant 8 by 8-foot (2.43 × 2.43 m) Kodalith gridwork which Grohe placed on an 8 by 8-foot light table illuminated from beneath with purple gels. The disks were placed on the surface and lit with individual spotlights to avoid unwanted reflections. Grohe then prepared a litho scratched in the appropriate areas to provide beams of gelled light landing on the eleven disks. On his copy stand, Grohe exposed the film of the disks, added the beams of light, and produced a highly individual and precise final image.

LASER BEAM, CIRCUIT, AND PROBES

For a brochure for Teradyne, Grohe was asked to depict the sensing operation of a laser beam as it modified the circuits in a wafer. Grohe wanted not only to portray this process but to inject his interpretation with drama and suspense. He first photographed a four-inch (10.16 cm) wafer straight on with 8 × 10 Ektachrome film, using photo-micrographic techniques in order to blow up the rectangular circuits. In their original form, each circuit was less than one-eighth inch (0.32 cm) in length. The finished transparency was placed on a light box. By employing theatrical gels behind a diffuser, Grohe was able to provide the variation of yellow to receding blue light. The blue gels created a striking contrast to the red laser and, because of the blue color's receding effect, also added to the feeling of dimension.

Using a 90mm lens on his 8 × 10 view camera, Grohe then photographed the transparency at a 45-degree angle to create the lines of perspective. On top of the image, he placed a piece of Kodalith film, masking the black probes which are used to indicate to the laser where modifications are needed by touching the reference pads in the wafer. Grohe then double-exposed a laser beam, which is actually a thin triangular shape sliced out of a piece of black paper photographed with red gel and a diffusion filter.

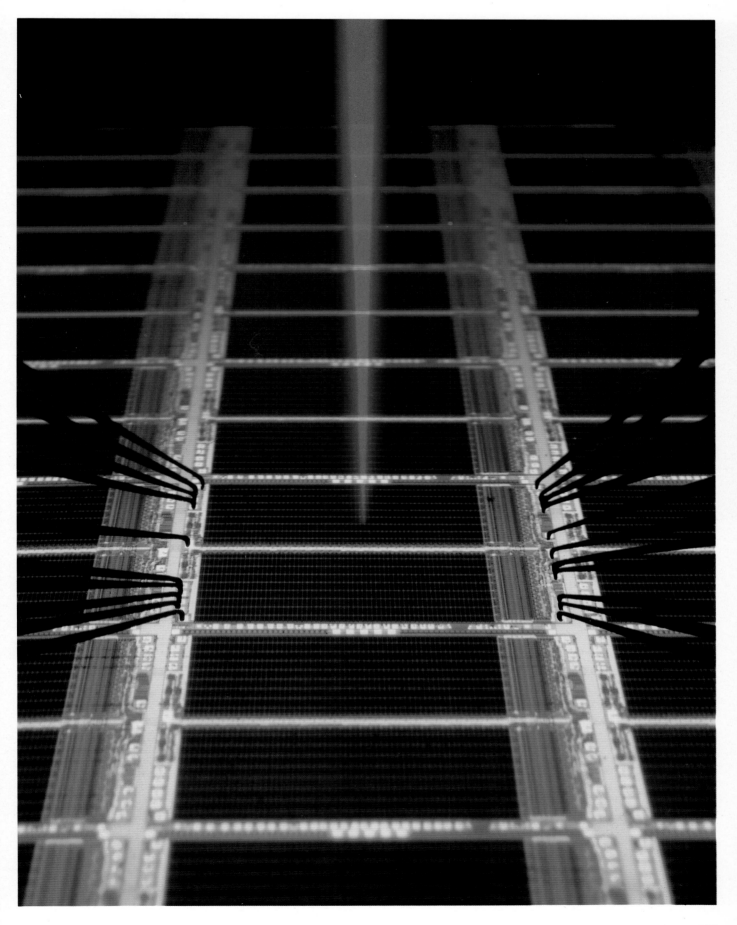

GROHE

DIGITAL (Spectrum '84)

To illustrate the Spectrum 84 computer conference, held annually by Digital Equipment Corporation, Grohe created this dramatic vision of the Spectrum logo racing up a long roadway to a generic city. He constructed the building of glass and used tape to mask off the window areas. Grohe then sprayed the structures with black Krylon paint, peeled off the tape, and the windows were complete. Next, he placed the "city" on a 12-foot-deep (3.65 m) platform and used plaster of paris to create a road, again spraying the surface with black Krylon.

Since the client had requested a textureless area surrounding the road, Grohe used dry cement powder which was sifted onto the platform and then very gently blown with an empty airbrush. He photographed the set with the 8 × 10 camera before making a second exposure of the five-inch-square (32.25 cm sq) logo, which was backed by strips of theatrical gel. The logo was placed on a small light box which rested on a 5 by 5-inch (12.7 × 12.7 cm) caster. Using a 90mm lens on the 8 × 10 camera to force the perspective and twisting the back of the camera to provide the visual distortion, he flashed a strobe in the light box to create a crisp image. Then, leaving the modeling light on in the box, he pulled the caster back under the camera and made an exposure at a 45-degree angle to create the shaft of moving light. For the Digital sign in the background, Grohe placed a Kodalith on the light box and photographed it at a distance of 15 feet (4.56 m), using theatrical gels and a diffusion filter over the lens. Since Grohe uses only electronic flash, even the tiny lights in the buildings were produced by strobes.

Because he prefers light to radiate in all directions rather than in a single ray, Grohe has created miniature strobes one-eighth inch (0.32 cm) in diameter which are powered by a 40-watt/second power supply attached to a five-foot (1.52 m) wire. These "micro strobes" can be easily tucked into small props such as the generic glass buildings.

SKYLINE AND COMPUTERS

On a rare location shot of the Boston skyline, Grohe transported the 8 × 10 Sinar view camera to a spectacular spot. Using a twinkle filter, he made a one-minute time exposure of the city lights. He then removed the filter and raised the back of the camera up to create the zoom of light soaring into the sky. Grohe combined the resulting image with two transparencies made earlier of two computers, as well as a transparency of a moon that had been airbrushed onto a sheet of black Plexiglas. Next, all four transparencies—moon, two computers, and skyline—were combined by using a copy stand and Ektachrome film. He then placed the Ektachrome on his copy stand, photographed it, and flopped the transparency to produce a mirror image superimposed on itself, creating this magical double-image effect.

COMPUTER SYSTEM WITH TERMINALS

To photograph all three-and-a-half tons of this computer equipment, Grohe had his massive subjects rolled on casters up ramps to a platform three feet off the ground. The structure was made of 2 × 4 plywood painted black, with the front edge painted white. He then constructed a 1 by 1-inch (2.54 × 2.54 cm) frame to replicate the horizontal lines of the tape drives, disk drives, and other equipment, and covered the frame with white paper. Next, Grohe created a spectrum shape from theatrical gels through which he projected a spotlight. Using a heavy diffusion filter over the camera lens, he made an exposure of the framework while the rest of the set remained in darkness. Grohe then removed the construction and made a crisp exposure of the computer equipment using a white spotlight. A third time exposure recorded the glowing screens.

COMPUTER, CREDIT CARDS, AND DATA

This photograph, comprised of five exposures, was made entirely in-camera for the cover of a Data General trade magazine. Grohe placed the company's terminal on a sheet of 8 by 16-foot (2.43 × 4.86 m) black Plexiglas. He photographed it straight on with one main light source, adding a spotlight covered with purple gels to create the background effect. He then made an exposure of the computer's display.

Next, Grohe took the set apart, placed the computer terminal on its back, and called up a different display. On the same piece of film, he photographed the display lettering that appears in the foreground by using a wide-angle lens aimed at a 45-degree angle. He then called up another display, shifted the camera to a slightly vertical position, and made a fourth exposure to provide additional lettering in the foreground.

For the fifth exposure, Grohe laid the various credit cards on a black Plexiglas background, turned the 8 × 10 camera upside down, and shot with polarized light to ensure that no density came through on the black areas. He wanted the blue and purple colors in the background to read through the cards, giving them a rather ghostly, ethereal appearance as they approached the horizon. The top portion of the image was left black to allow for the magazine's logo.

COMPUTERS ON A RED LOOP

This Apollo Computer Company trade magazine cover, which is a compilation of twenty-two discrete exposures, provided a symbolic depiction of the manner in which computers "talk" to one another on what industry afficiondos call "the ring." To create the red loop, Grohe drew a circle with india ink on a piece of paper. Then he made a negative image, or Kodalith, which gave him a transparent area where he would place the red. He rephotographed with red gels and a diffusion filter over the lens. The purple horizon line was generated in the same way.

Grohe then photographed the screen displays with his 8 × 10 camera and placed the resulting transparency on a small light box which was positioned on a rolling mechanism made from casters. Grohe rolled the transparency forward, and at predetermined points, made exposures with strobe light. Between these crisp exposures, he left the modeling lamp of the light box on to create the continuous shaft of light. With the incandescent bulb of the modeling light on and the lens open, motion was repeatedly registered on the film. At predetermined intervals, the strobe light was activated in the darkened room as the light box was pulled down a track, registering a static image. Gels created the color variations on the light "whizzes," and each discrete image was exposed on a separate piece of film.

For the display on the foreground terminal, Grohe stripped together four photos to make a single transparency. All of the film was then stripped into three separate pieces—the computer terminals, the horizon line with the whizzes, and the red loop. By using a selective Kodalith masking process in order to hold back light in certain areas, Grohe ensured that the computer terminal would appear to be in front of the red ring rather than behind it in the final image.

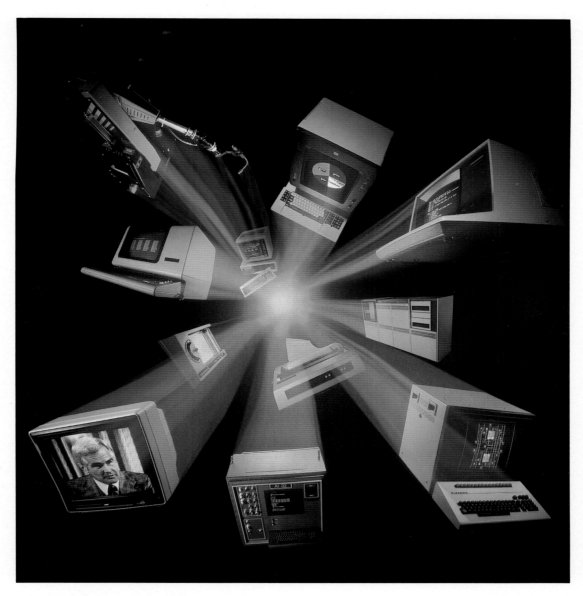

COMPUTER SOFTWARE PRODUCT LINE

Grohe created this startling computer display to illustrate various software products available from one company. His first step was to draw a 20-inch-square (50.8 cm sq) layout which was used to measure the perspective as he made separate shots of the computers. Since five of the images were shot on location and six in the studio, Grohe cut out Polaroid pictures made at each session and placed them on the layout to ensure a consistent vanishing point. Grohe also used the same emulsion batch of film and the same theatrical gel package to maintain coloration.

After photographing each computer with the 8 × 10 camera, Grohe stripped together two groups of transparencies and assembled them in an inner and an outer ring in the studio. He then set up a zoom platform for his camera to facilitate the rephotographing of the transparencies. Next, he placed the transparency of the outer ring on a light box and made a crisp exposure. Then, leaving the shutter open, he dollied the camera about 20 feet (6.09 m) creating the columns of moving light. Grohe repeated the procedure, using the transparency of the inner circle of images. A third image recorded the dramatic center fireball, which was provided by a hole cut in a piece of black paper backed by theatrical gels and shot through a diffusion screen. The final duplicate transparency of three exposures—the inner ring, the outer ring, and the fireball—actually contained within it eleven discrete exposures, as well as strip-ins of several of the screen displays.

MODEL OF AN AIRSHIP

This self-promotion piece demonstrates Grohe's model-making skill as well as his knack for creating believable environments within his studio. Grohe constructed a 24-inch (60.96 cm) precise scale model of a Lebaudy airship which was originally built in 1903 near Paris. The airship was suspended on monofilament wire in front of an 8 by 8-foot (2.43 × 2.43) Plexiglas sheet airbrushed with translucent lacquers. On the Plexiglas, a sun was painted and lit from behind with a strobe to produce a vibrant color-saturated backdrop. In the lower left-hand corner of the set, Grohe positioned a castle—originally a dollhouse made for his daughters—which was placed on 2 × 4s a foot above floor level. Underneath the lumber, he bent plywood boards in order to create a chute directed up toward the back of the castle.

To create the layers of billowing clouds, Grohe aimed two giant-sized CO_2 fire extinguishers into the setting. As the CO_2 gas "whooshed" up behind the castle, it tripped a thin light beam which was created by a slide projector on the left side of the set. As the gas hit a photocell, it triggered the camera and the synchronized strobes popped. Each time an exposure was made, the sound of gas and the motion of clouds was so intense that it seemed the airship must be rising up into the French sunlight. Indeed, clients asking to use this image have been known to inquire where Grohe found such a unique location in Boston and at what time of day he found such luscious light.

A SATELLITE DISH

In this image of a satellite tracking dish, Grohe wanted to produce a romantic vision, subtly reminiscent of the early color processes. The photograph is actually a combination of four pieces of black-and-white film, a sheet of theatrical gel, and a crescent moon—all made in his studio.

Grohe first shot the dish, adding opaque tape to the transparency to slightly modify the design of the original and thus avoid copyright problems. The image was made into a litho, or black image, on a clear piece of film. From his studio window, Grohe then made exposures of three different buildings and combined the resulting lithos with the satellite dish, precisely aligning the images with a pin register system. Then, with the aid of a sheet of diffusion material and colored gels, Grohe created the colorful sky. To diminish the intensity of the buildings, Grohe then removed the buildings on the right-hand side and those in the distance, and laid down a sheet of purple gel which lightened the black-and-white areas and strengthened the overall impression of color. Lastly, he added an exposure of a fragile moon which had been painted on a large sheet of Plexiglas.

A COMPUTER BATTLE

For a Data General Corporation trade magazine cover, Grohe was asked to illustrate the "great shoot-out" between mini-computers and micro-processors. Although the client had originally envisioned a western gun-slinging scene, Grohe opted for the classic naval battle between the Monitor and the Merrimac. The two-foot-long (0.61 m) model ships were made of fiberglass with actual Polaroid photos of computers pasted on them. To provide rivet heads, Grohe used several thousand common pinheads. He floated his ships in a sea of gelatin to create the impression of water in motion and used dry ice to provide mist. To create the burst of flame emerging from the brass tube gun barrel, Grohe poked some steel wool into the barrel and lit it with a match. An exposure was made in total darkness to capture the glow, and cigarette smoke was blown through rubber hoses placed out of camera range. Blue seamless paper provided an uncluttered background for the magazine's logo. Although the client was somewhat perturbed that Grohe had illustrated the concept with replicas of ships that ended up as scrap metal at the bottom of the sea, Grohe convincingly pointed out that the company should hope that its computers would one day be obsolete—so that a whole new generation of products could then be marketed.

SPACE BATTLE

This computer game package image, made for Parker Brothers, was the result of eight photographs craftily woven together. Both spaceships were constructed of bits and pieces from various model kits. The "good guy" ship, an 18-inch-wide (45.72 cm) piece of Styrofoam covered with fiberglass, was photographed first, with a flashlight bulb placed in the driver's seat. The "bad guy" ship required three exposures on one sheet of film. Along with the kit pieces, Grohe used auto putty for the nose of this ship, Polaroid print coaters for the fuel tanks, and a Ping-Pong ball for the center. The rear of the ship was made of cut and burned Plexiglas tubing, and a soldering iron was used to burn a hole in the ship so that a micro strobe, covered with a gel, could be placed inside to simulate a flame. Grohe made a time exposure of the main "bad guy" ship, one of the fire in the fuel tank, and another of the blue "whiz," created by a micro strobe in the tail piece shot with a blue gel and fuzz filter. Since each part was photographed separately, to maintain consistent illumination Grohe used spotlights covered with orange and yellow gels to create the appropriate reflections.

Grohe's next step was to create the center explosion, which was made by using two sheets of Plexiglas topped by a tuft of cotton and sprinkled with bits of metal and ashes. A test tube containing a micro strobe was placed in the center, and the exposure was made with an orange gel. Laser beams were then created by cutting slits into black paper and photographing them with orange gel. A seventh exposure recorded the earth—in reality a Plexiglas sphere airbrushed with land masses and clouds. The final exposure captured the stars, which were generated by a piece of clear acetate that had been splattered with paint, and reversed by contact printing onto litho film.

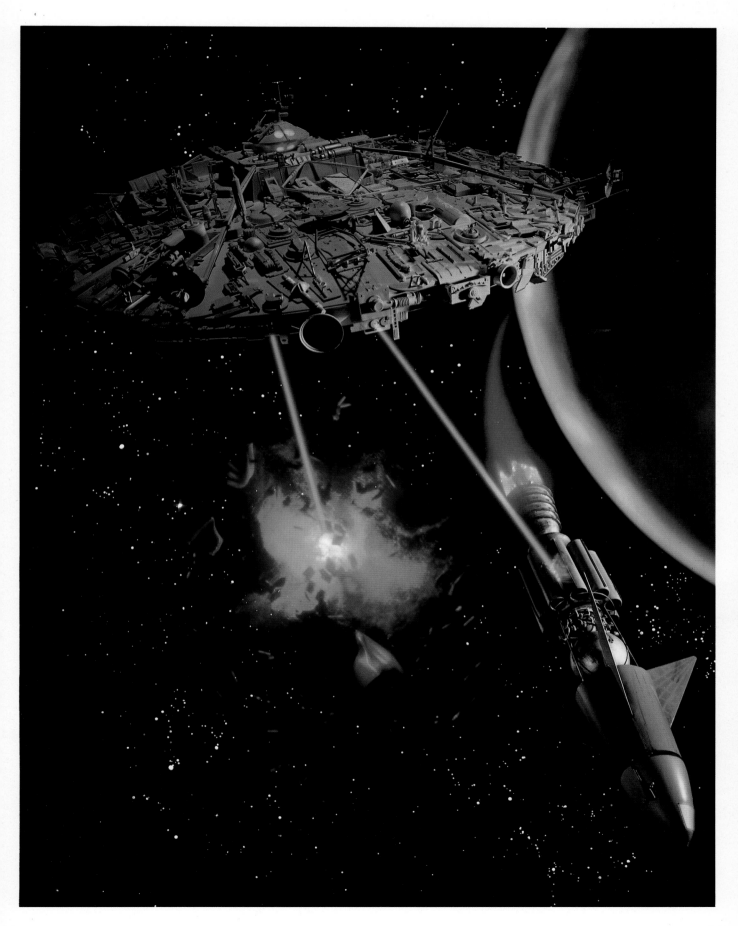

TECHNIQUE
SPACE BATTLE (PARKER BROTHERS)

Although the final photograph is composed of eight separate exposures, these four photographs show the varied techniques that are necessary to produce the finished image.

Grohe first constructed a model (*upper left*) that closely resembled an actual spaceship. He created the explosion (*middle left*) by placing cotton, metal, and ashes between two sheets of Plexiglas and then lighting the setup from below with a micro strobe covered by an orange gel.

The separate transparencies are then combined on a duping machine (*bottom left*), rephotographed, and finally retouched (*bottom right*) before the photograph is considered complete.

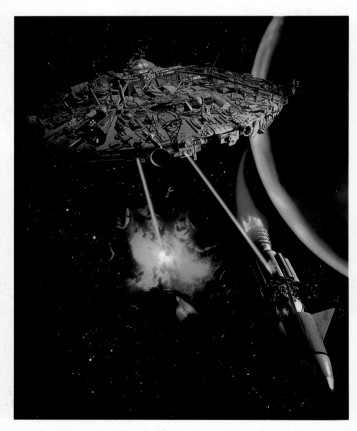

Jayme
ODGERS

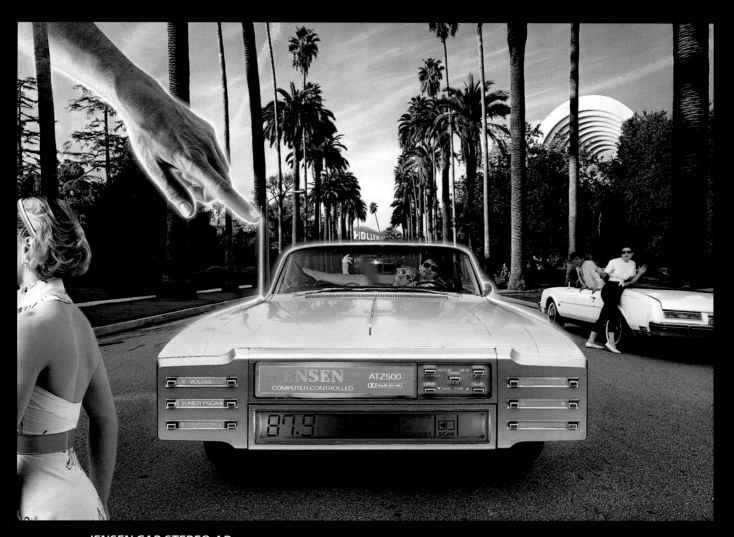

JENSEN CAR STEREO AD

Benton & Bowles, Chicago, provided Odgers with a sketch for a surrealistic view of Los Angeles, wanting "a real LA scene." All Odgers had to do was find the right location, the right car—and make the magic. He finally came up with a palm-lined street in Beverly Hills and a white 1963 Buick Skylark, which was later dyed pink on the dye-transfer print. The car hood perfectly matched the outline of the stereo so the front of the car was jacked-up to allow a proper angle. He then got some friends and one professional model to enact this outlandish and fun scene. The stereo equipment was photographed in the studio and later photo-composited together with a blue sky and a magical hand touching the antenna. A retoucher added the silver-glow outline, the HOLLYWOOD sign, and the Hollywood bowl in the background.

Jayme ODGERS

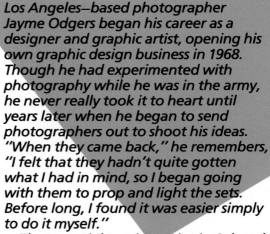

Los Angeles–based photographer Jayme Odgers began his career as a designer and graphic artist, opening his own graphic design business in 1968. Though he had experimented with photography while he was in the army, he never really took it to heart until years later when he began to send photographers out to shoot his ideas. "When they came back," he remembers, "I felt that they hadn't quite gotten what I had in mind, so I began going with them to prop and light the sets. Before long, I found it was easier simply to do it myself."

The essential turning point in Odgers' career, however, came when he decided to take some time off from work. He traveled around the world and in 1976 made a sojourn to the Southwest desert. For three months he spoke to no one, spent his nights in a sleeping bag, and made pictures of everything he saw. "Finally I was just a being just being," Odgers muses. "It was then that I seriously began pursuing not being so serious." When Odgers returned to Los Angeles, he decided to throw himself wholeheartedly into photography and soon was shooting for such record companies as Capitol, Columbia, and Warner, as well as for such clients as IBM, Max Factor, Pacific Telephone & Telegraph, Wet magazine, Chanel, and many others. People were certainly taking Odgers seriously, whether he expected them to or not.

From the beginning, Odgers' work was steeped in special effects. "I have always loved the idea of illusion in photography," he explains, "because photography is so real. It has an inherent veracity that people automatically believe. So when you add illusion to a photographic image, it becomes very mystifying." In fact, to Odgers, photography is much like reading a mystery novel. "You just start

with the first page and one thing leads to the next. You never know exactly where you'll end up."

Because of his clients' needs, however, Odgers must occasionally previsualize and sketch most of his work. His art background—he studied at the Art Center School in Los Angeles—has been a definite advantage in Odgers' success at making his ideas work. His extensive design and graphic arts experience, along with a two-year apprenticeship with graphic designer Paul Rand, has also helped to make Odgers' photography so unique. His knowledge of offset printing, four-color separations, airbrushing, and bleaching and dyeing—learned on the job as well as on his own—makes him a consummate master of his craft. "Being able to move from one area to the next is the most important part of my work," Odgers says. "I call it cross-pollinating—to take something from the realm of the retoucher, the graphic artist, or the printer, and bring it into the world of the photographer." Quite often Odgers will airbrush graphic elements on his photographs, or he will airbrush directly on the objects to be photographed. He heightens colors with oils, pigments, or transparent dyes when necessary. Because he considers himself to be an artist first and photographer second, Odgers isn't timid about manipulating his photographs in such unusual ways. Although his approach is undeniably photographic, he never allows traditional methods to inhibit his sense of adventure. Rather, Odgers combines the best of many worlds in his images.

In Odgers' pictures, objects characteristically leap forward or backward into space. Sometimes his subjects seem to have a life of their own. Tipped or tilted at unusual angles and positions, the parts of his photographic puzzles are imbued with a strange kind of energy. Odgers is philosophical about his artistic approach. "We think there are four points to a compass," he reflects, "but the Hopi Indians believed there were six—north, south, west, east, and up and down." Odgers has adopted this belief in his work and always tries to make his images read "in and out" as well as from left to right and from top to bottom. "Placing the objects at unconventional angles and overlapping can energize and dimensionalize an image in an uncanny way," he explains. "I have rebelled from the graphic designer's tendency to regard everything in a flat manner. I don't want to produce static images."

Odgers' ability to incorporate different realms in his work is reflected in the diversity of his clients and assignments. The recipient of over seventy national and international awards, Odgers responds to the needs of corporate clients, artists, and magazines; his photographs have been shown at such prestigious museums and galleries as the San Francisco Museum of Modern Art, the Walker Art Center (Minneapolis), and the Montreal Museum of Fine Arts. He was commissioned to produce an official art poster for the 1984 Olympics in Los Angeles. Clearly, Odgers has crossed the boundary between commercial and fine art photography, using special effects as his bridge. "Now I feel I am dispensing with career number two, photography per se, and am moving to a career number three—that of being an artist. Hopefully this will allow me to combine all three of my careers," he explains. However Odgers describes his particular artistic journey, one thing is evident; he has enhanced his work with the methods, materials, and techniques of many artistic fields, without ever overshadowing his rare and quite wonderful photographic vision.

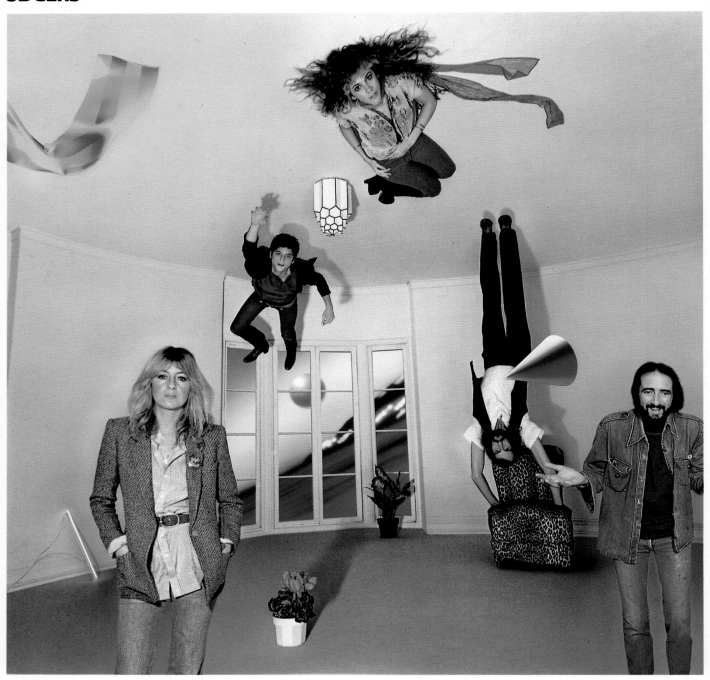

TUSK—FLEETWOOD MAC

Odgers was assigned to photograph Fleetwood Mac for an album cover; he wanted them to be floating in the air in his studio. Odgers devised a special effects scheme to solve his problem. First he painted the ceiling of the room dark gray and placed white seamless on the floor. Because we are psychologically oriented to white ceilings and dark floors, the illusion was off to a convincing start.

Then he set a ceiling fixture in the floor and cast a plant in plaster of paris to enable him to screw it into the ceiling to add to the illusion. He managed to get various members of the group in the room at different times. He asked Mick Fleetwood to hold a chair up to the ceiling, while Stevie Nicks positioned herself on the floor. Additional members of the group were photographed individually and stripped in to the final dye transfer print.

Perhaps the most intriguing aspect of the shot is the manner in which illusion and reality interact. "It's a bit like magic," says Odgers. "The eyes are directed to the ceiling to find the trick, when in fact the upper portion of the image is the reality and the trick is happening elsewhere."

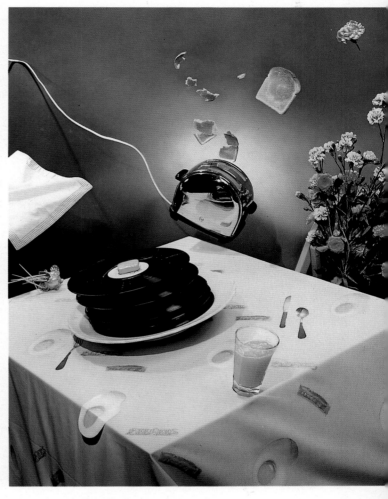

BEE GEES: THANKS FOR GETTING EVERYBODY UP

Created for an Album Graphics Inc. ad placed in an issue of *Billboard* Magazine devoted exclusively to the Bee Gees, this image was intended to illustrate the fact that the rock group's albums were selling like hot cakes and accompanied the copy "Thanks for Getting Everybody Up." Odgers filled in the details, creating a custom-made photographic breakfast scene. After photographing some fried eggs, bacon, and silverware, Odgers had his 35mm slides copied onto decal material that could be ironed onto the tablecloth.

A Dali-esque egg was allowed to drip off one edge. Odgers made a trip to Chinatown to find a plate large enough to accommodate the stacked LP's. Butter was molded from yellow spray-painted clay, and a 1940s-style toaster lit with an interior red lightbulb set the mood. Toast was suspended from monofilament wire that was later retouched out of the dye transfer. The image was shot with tungsten lighting and a Pentax 6 × 7 camera.

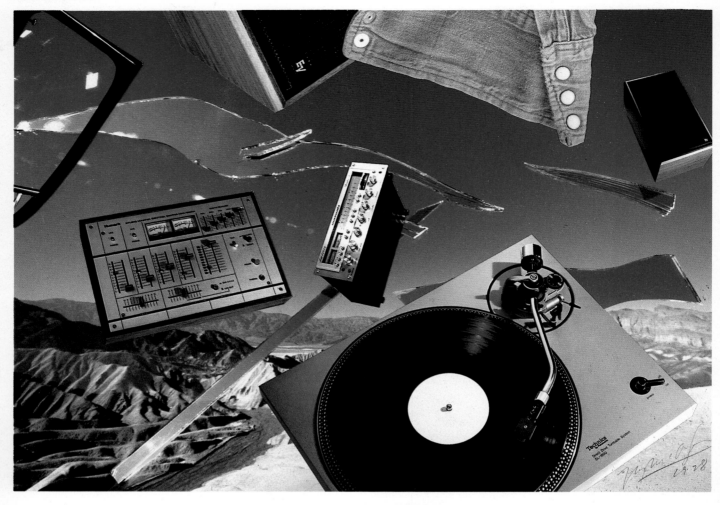

HI-FI HIGHWAY

The image shown above is a classic example of ingenious recycling. Originally intended as an album cover for the English singer Ian Mathews, the photograph at first featured portraits of the recording artist.

Odgers had made the first photograph in the desert, using a rather unusual method. He mounted a huge piece of glass on weighted stands, tying the corners to large rocks to keep the glass stationary when the desert wind blew. Then he glued broken mirrors to his construction, which reflected the sky when Odgers aimed his camera through the glass. Polaroids of the singer were also glued in position as well as held in each hand, and the entire photographic sculpture was shot with a 35mm Nikon and 15mm lens. Odgers released the shutter with a bulb-release in his mouth. Later, when the picture wasn't used as a cover, Odgers kept it in his portfolio. When *Rolling Stone* called urgently needing an image for a page on stereo equipment, Odgers decided to recycle his idea. He collaged prints of the stereo equipment on the Type C background print to create a new showplace for a tried-and-true concept.

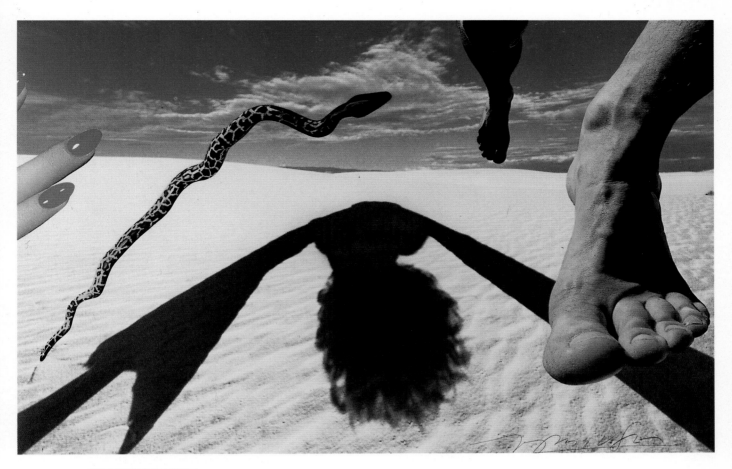

BORROWED TIME

Used for a Johnny Rivers album called *Borrowed Time*, this photograph was actually a combination of inspiration and collage. Odgers had been camping out in the desert when he decided to shoot his shadow through his legs at sunset. This was combined with another desert image of his feet. He accomplished this odd perspective by digging a shallow hole, placing the top of his head in it, and looking out through the 15mm lens at ground level. This image was pasted onto a photograph of his shadow that he shot through his legs at sunset. A hand and snake were cut from magazines and added to the final print to make this view even more startling.

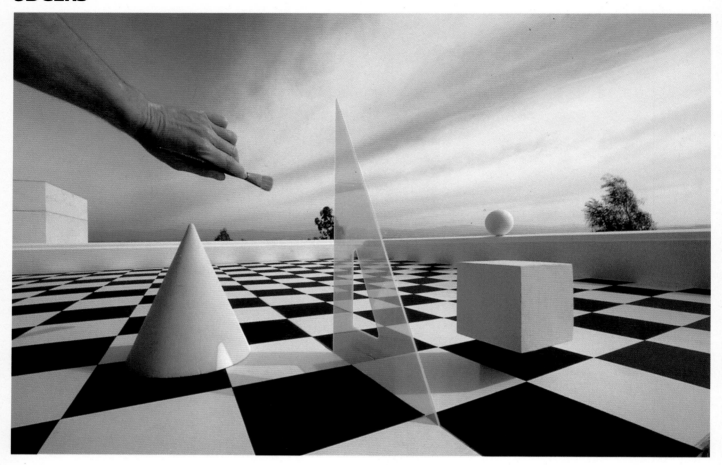

ART AND DESIGN

This surrealistic landscape, shot for a California Institute of the Arts brochure, combines the best of the Bauhaus with a natural outdoor background. Odgers constructed an 8 by 8-foot (2.43 × 2.43 m) platform which he positioned tightly against a balcony handrail. He covered the table with black and white construction paper in a checkerboard design and added the geometrical wooden and plastic shapes. Using natural lighting, Odgers shot the set with his Nikon 35mm camera using his 15mm flat-field lens to provide a distorted sense of dimension. The result was a strong graphic image that blended the miniature set perfectly with the great outdoors.

ARTISTS AND TRADESMEN

Shot for a Los Angeles interior design directory, this photograph was used on a page entitled "Artists and Tradesmen." Odgers felt that an image with an airy, blue-sky, "no-limit" approach was just right. He constructed a 3 by 3-foot (0.91 × 0.91 m) set and positioned a crystal ball, a Polaroid print, a palette, a paintbrush, and a cardboard stairway. A black, painted brushstroke was cut from cardboard and supported by a straight pin in the floor. Odgers used a minimal amount of tungsten lighting, which allowed him to visualize the result without taking a Polaroid. Odgers shot the set with a 35mm Nikon using a 15mm lens to maintain maximum depth of field. Next, he went through his stock file and located an appropriate blue sky print to which he glued the print of the foreground elements. As a final touch, Odgers airbrushed yellow, green, and red geometric shapes on the composite C prints. The image made a strong graphic statement about two limitless and visionary worlds.

ODGERS

FESTIVAL OF FESTIVALS 1982

Odgers originally constructed this 3 by 3-foot (0.91 × 0.91 m) set for a photograph used as a divider page image for an interior design trade sourcebook to illustrate the word *information*. When the Toronto film festival saw the image, they requested a similar shot for their poster and publicity materials, so Odgers modified his idea and changed the word *info* to *film*. The wooden Saturn remained in its place, as did the cardboard staircase, but *info* became *film* with a shadow cast from the limelight of the film strip "i," and the shadow cast by a red-orange triangle created the suggestion of an "m." Odgers made the changes by airbrushing on an 18 by 24-inch Cibachrome copy print of the earlier image, which was originally shot with a 35mm Nikon and 15mm wide-angle lens.

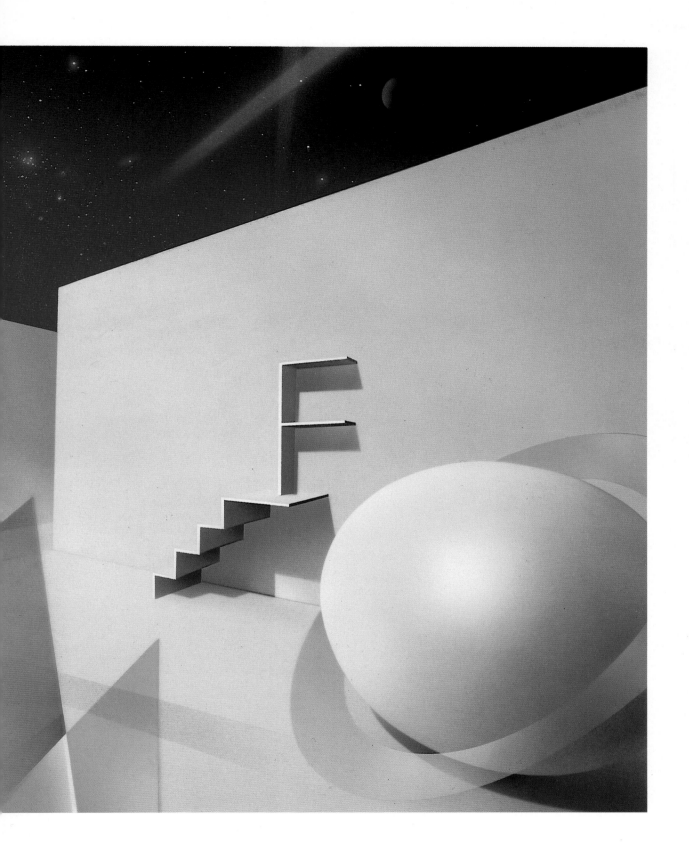

NY IN LA

Although the client originally envisioned an apple
inside an orange peel, Odgers felt that this image
more clearly represented the concept of New York in
Los Angeles, where the New York Art Directors Club
was showing for the first time in its sixty year history.
"The higher the point of view, the bigger the apple,"
remarks Odgers. Odgers went to the beach early one
morning and climbed up onto the roof of the public
restroom to get a dramatic angle. He shot the scene
with his Pentax 6 × 7 and a wide-angle lens, placing
the palm tree in the center of the frame.

Back in his studio, Odgers set a glistening apple,
purchased at the Farmer's Market, on a piece of sand-
brown seamless. He used tungsten lighting to
brighten the fruit and create the illusion of sunlight.
The two transparencies were then combined at a
printmaker's, and one-half of the first transparency
was flopped to the other side of the palm tree to
provide a double-vision effect. A shadow beneath the
apple was added by a retoucher, and Odger's
rendition of Manhattan West was complete.

CLOSING CEREMONIES: GAMES OF THE XXIII OLYMPIAD

Odgers combined seven separate shots in the photograph, originally made for the closing ceremonies of the Los Angeles Olympics. First he shot the foreground buildings and statues with his 6×7 Pentax, using a fisheye lens for the bent perspective. A sunset, soccer ball, poster, kiosk, Olympic closing ceremonies ticket, and gold medal were shot and collaged together on a Cibachrome print. A Hasselblad $2\frac{1}{2}" \times 2\frac{1}{2}"$ was used for the ball, and a Nikon with various lenses for the smaller objects.

To create the bursts of red fireworks in the sky, Odgers sprinkled sodium dithionite, a granular chemical, on the print to remove all but the red emulsion layer. The longer streaks of light were airbrushed. Odgers had photographed the background image of the Coliseum two days before the Olympics had actually begun. As he watched Rafer Johnson light the Olympic flame, he realized his print was missing that most vital element. At the last minute Odgers shot a Polaroid off the television for reference and airbrushed a flame onto the Olympic torch.

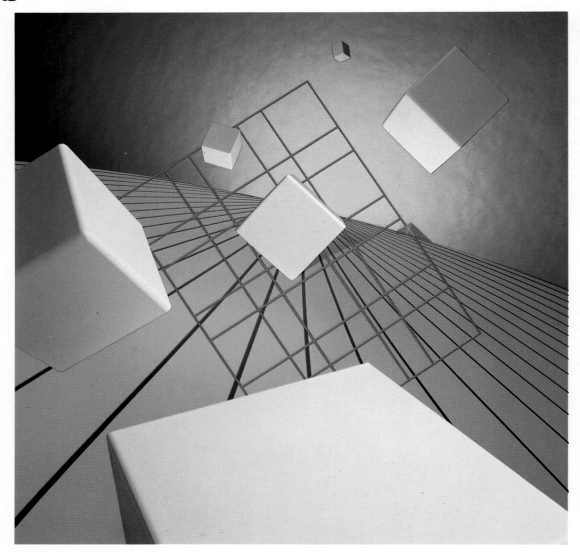

INNOVATION

When Odgers was asked to illustrate the theme "innovation" for a Pacific Telephone & Telegraph brochure, he decided that the keys of a telephone floating elusively into space would symbolize the client's message. Three-sided white wooden blocks from an inch to a foot in size were placed on slim rods at different heights and shot with a Pentax 6 × 7 camera and fisheye lens. Odgers then photographed an arched 4 by 8-foot (1.22 × 2.43 m) sheet of Plexiglas lit from beneath with an orange gel. Silver Mylar tape was added to create the illusion of depth on the surface of the Plexiglas. The two images were photo-composited with a shot of blue seamless delicately lit with a low white spotlight. The final composite image provided a surrealistic and mysterious sense of time and change.

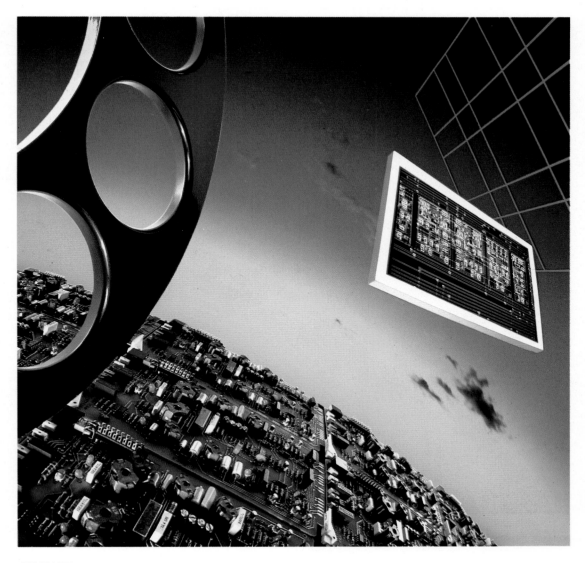

CHANGE

For this unusual image, created for Pacific Telephone and Telegraph, Odgers first presented his client with a subtle watercolor sketch. He then created a template which he used on his camera to ensure that the various elements would fit perfectly together in the final print. The telephone dial was actually a six-foot wooden model which was sanded and painted with black lacquer. To create the "circuit world," Odgers placed sixty-four telephone circuit panels on a table and shot the arranged pieces with a fisheye lens on his 6 × 7 Pentax. He lit the circuits with a warm light on one side, a cool light on the other, and added a bit of green gel to create a natural effect. Green lines were produced by the use of a black-and-white drawing which was made into a film negative photographed on a light table with a green filter. A

micro chip—actually an 11 × 14-inch transparency from a 35mm slide provided by the client—was photographed at an angle on a light table, positioned properly with the help of the template. The circuit world, dial, chip, sheet of white cardboard backing the chip, and green laser lines were then photo-composited to make one transparency with the sky.

The sky was the portion of the image Odgers found most difficult to achieve. Each day Odgers would drive thirty minutes to a lovely cliff in Santa Monica where he'd wait for the perfect sunset. Unfortunately, the weather wasn't always on his side, but after a week of waiting, the golden glow was just right. Odgers set his camera on a tripod, bent a Mylar mirror in his hands to match his template, and clicked the shutter with the help of a cable release held in his mouth.

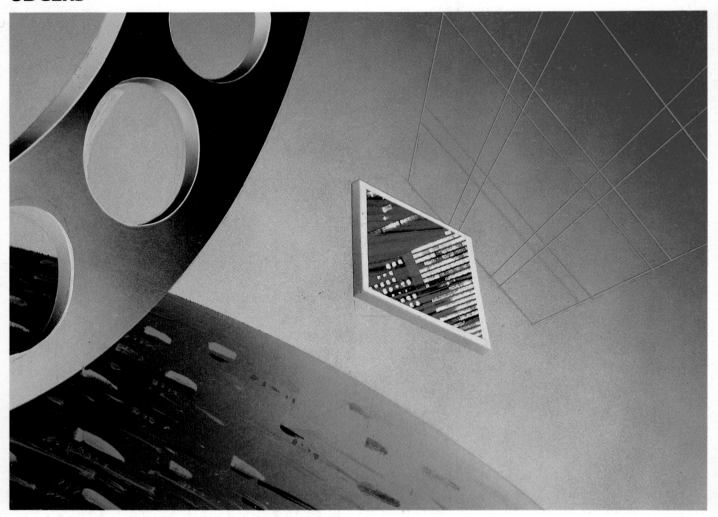

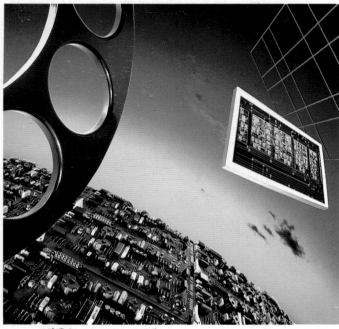

TECHNIQUE
GRID, CIRCUITS, AND TELEPHONE DIAL

Drawing on his background in the graphic arts, Jayme Odgers often takes the opportunity to work out initial ideas in other mediums. In this instance, he used a watercolor sketch as the blueprint for his idea. Adjustments were then made in the sketch to accommodate the actual components used in the final photographic image. The changes were made to suit the photographic medium, but the conceptual idea remains the same.